IMAGES
of America

THE FIVE TOWNS

D1196655

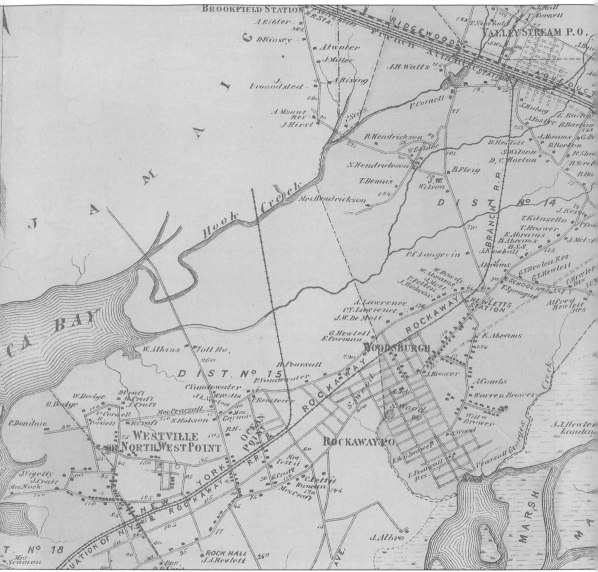

The 1873 Beers, Comstock, and Cline map of southern Hempstead shows the communities of Hewletts, Woodsburgh, Ocean Point, Lawrence, and North West Point. The newly established South Side Railroad Rockaway Branch depots gave new names to these old settlements. They would later be known as Hewlett, Woodmere, Cedarhurst, Lawrence, and Inwood—Long Island's Five Towns. (Hewlett-Woodmere Public Library Local History Collection.)

ON THE COVER: Generations of vacationers, like these young men from Brooklyn, came to The Branch for a day or for the season. The beautiful, unspoiled country setting provided opportunities for boating, fishing, and socializing away from the heat and noise of the city. Many liked it so much they decided to stay. (Hewlett-Woodmere Public Library Local History Collection.)

IMAGES
of America

THE FIVE TOWNS

Millicent Vollono

ARCADIA
PUBLISHING

Copyright © 2010 by Millicent Vollono
ISBN 978-0-7385-7329-8

Published by Arcadia Publishing
Charleston SC, Chicago IL, Portsmouth NH, San Francisco CA

Printed in the United States of America

Library of Congress Control Number: 2010920197

For all general information contact Arcadia Publishing at:
Telephone 843-853-2070
Fax 843-853-0044
E-mail sales@arcadiapublishing.com
For customer service and orders:
Toll-Free 1-888-313-2665

Visit us on the Internet at www.arcadiapublishing.com

For my parents, who taught me the lyrics. For Phil, who gave me the music. For our children, who will sing the songs.

CONTENTS

ACKNOWLEDGMENTS

The task of compacting the stories of many communities over several centuries into one small volume cannot be approached without optimism, humor, and many supportive associates. Members of the Bedell, Bowker, Brower, Combs, Hewlett, Ike, Jennings, Longworth, and Pearsall families have generously shared their memories and photographs. Others with names less familiar to students of Long Island history—Adams, Feeney, Goldberger, Goodman, Domanico, Parise, Perone, and Sarro—have been equally generous. Michael Goudket's encouragement and technical support have been invaluable. Authors George Fisher, Salvatore LaGumina, James P. MacGuire, Natalie Naylor, and Raymond and Judith Spinzia have kindly shared with me their knowledge, wisdom, and experience. Rosalyn Sloss, for many years curator of the Hewlett-Woodmere Library's Local History collection, has been not only a good friend but an invaluable source of information and referrals. In addition, gratitude goes to Rebekah Collinsworth and Jim Kempert, my editors at Arcadia Publishing, for their cooperation, encouragement, and hard work on my behalf. Any errors are my own

I would like to acknowledge the assistance of the following institutions: Hewlett-Woodmere Public Library, Local History Collection, Hewlett, NY (HWPL); Queens Library, Long Island Division, Jamaica, NY (QL-LID); Long Island Studies Institute at Hofstra University, Hempstead, NY; Nassau County Department of Parks, Recreation & Museums, Photograph Archives Center (NC-DPRM); The Society for the Preservation of Long Island Antiquities (SPLIA), Cold Spring Harbor, NY; Library of Congress Prints and Photographs Division, Washington, D.C. (LC-PPD). Photographs from these collections are credited as shown above in parentheses.

Thanks also to my colleagues, both past and present, at the Hewlett-Woodmere Public Library for their support. Unending appreciation and love to my children, who gave me the confidence to attempt this project, and to my husband, Phil Vollono, who has always encouraged my adventures and graciously suffered the consequences of his kindness.

INTRODUCTION

*Their nearness to the ocean and their accessibility to the great
metropolis made of them a unique community.*

—Dr. Benjamin Allison on the Five Towns (1952)

Driving down Broadway, the route of the old Indian path that stretched from Hempstead to Far Rockaway, it is hard to believe that paved roads were rare here through the 1920s and that horses were still a common sight through the 1940s. As convoys of SUVs battle for dominance on Peninsula Boulevard, or shoppers try to park on Broadway or Central Avenue, it is unimaginable that this landscape was *ever* pristine meadow inhabited solely by cows.

The Rockaway Peninsula, historically referred to as The Rockaways, is one of the oldest population centers on Long Island. For millennia, it attracted Native American and then colonial settlement because of the wealth of its natural resources. The tides sculpted the shorelines, creating bays and inlets, and dictated the fortunes of farmers, merchants, and seamen. The Rockaways' Loyalist majority maintained an allegiance to Great Britain and resisted the change the American Revolution would bring. Col. Richard Hewlett of Near Rockaway (d. 1789), a veteran of the French and Indian War, led troops that inflicted great damage on the colonial militia. Implicated in a plot to kidnap Washington, Hewlett fled to Canada. Members of his family returned; others remained and prospered throughout Long Island.

In the 19th century, the allure of the shore as a vacation area brought investment and further settlement. Celebrities like Oscar Wilde, Theodore Roosevelt, Diamond Jim Brady, and Lillian Russell vacationed in the area that locals referred to as The Branch. Captains of industry, government, and finance journeyed to enjoy the diversions of the Rockaway Hunting Club, the Woodsburgh Pavilion, or the Holly Arms Hotel, and many stayed and settled in the communities. Soon manicured lawns, steeplechase tracks, and railroad stations appeared where cattle and sheep once grazed. Private docks took the place of oyster shacks as the land became more valuable than anything grown or built on it. A microcosm of New York City, The Branch became The Five Towns (and then more than five) as local governments were created to supply the services that a growing population required.

In 1683, when the New York colony was partitioned into counties, the town of Hempstead belonged to the County of Queens. Though there was interest in separating as early as 1859, it was not until 1898, when the western part of Queens (including The Branch) became a borough of New York City, that a serious movement began to establish an independent Nassau County. On January 1, 1899, the law creating that county took effect, and in that year Assemblyman George Wilbur Doughty of Inwood introduced successful legislation to return Elmont, Foster's Meadow, Lawrence, and Cedarhurst to the town of Hempstead.

The success of the railroads had changed not only the names of the villages, but made the transition from meadow to golf course to shopping mall inevitable.

Alfred Bellot's 1917 *History of the Rockaways* is the principal source of information on the area. Combining information from earlier written histories with contemporary information, Bellot, a journalist from Brooklyn, produced a detailed and comprehensive work, still valuable for its scope. In 1941, the New York State Writers' Project produced a concise, readable chronicle of the development of the Five Towns communities for the WPA. Narratives by Benjamin Allison, Charles Hewlett, Richard Brower, Jeffrey Wexler (a.k.a. "Captain Tim Brower"), Mark Lindenbaum, Joel Morris, and Rob Snyder remind modern readers of the area's rich history. Regional newspapers—*The New York Times*, the *Brooklyn Daily Eagle*, *The Wave*, the *South Shore Record*, and incarnations of the *Rockaway Journal* as it became the *Nassau Herald*—have documented the allure of the place, which attracted generations of travelers from all parts of the world.

This volume focuses on the early history of the villages and will set the stage for the changes in population and development that followed World War II. It does not replace, but hopefully enhances previous works by expanding on some of the people and places they reference. It is this auathor's hope that it will stimulate scholars to further examine the area, its people, and its heritage.

One

"Blessed with Peace and Plenty"

Daniel Denton described Long Island's south shore with these words in his *Brief Description of New York* (1670). Though Denton's book was actually a promotional pamphlet designed to encourage English settlement in the New World, the island did closely resemble its description—an unspoiled land of temperate climate where natural riches abounded.

Most of today's Queens and southern Nassau were first inhabited by the indigenous people that the European settlers called Rockaway Indians. Primarily farmers, they supplemented their diet with fishing and hunting. "Rockaway" may have been derived from the Algonquian words *Reckouwacky* (the place of our own people), *Reckanawahaha* (the place of laughing waters), *lekau* (sand), or *lechauwaak* (fork or branch). Their *wikki-ups*, or wigwams, were made of bark and reeds placed over a frame of saplings. Wampum was a principal means of communication and currency for the coastal tribes, who manufactured wampum beads from shells. Eventually the tribes traded wampum belts for goods from the Dutch, who then used wampum to purchase furs from the inland tribes.

For over 50 years after Henry Hudson's 1609 exploration of the river that would bear his name, colonial Dutch governors negotiated with the sachems of the Native American tribes for trade and use of the land of western Long Island. The early interactions between the Dutch West India Company and the local inhabitants were sometimes marked by conflict. While trade benefited both communities, individual disputes often led to clashes and some escalated into war.

In 1643, English colonists led by Rev. Robert Fordham and John Carman negotiated a treaty with the native tribes that eventually granted the English rights to use all the land from the East River to Martin Gerritson's Bay (today's Oyster Bay Harbor) and including the area known as the Great Plains (later the Hempstead Plains) south to the ocean. In 1685 John Palmer purchased most of the Rockaway Peninsula from the Rockaway Indians and their sachem, Tackapausha, and, in 1687, sold the property to Richard Cornwall, a Quaker of Flushing.

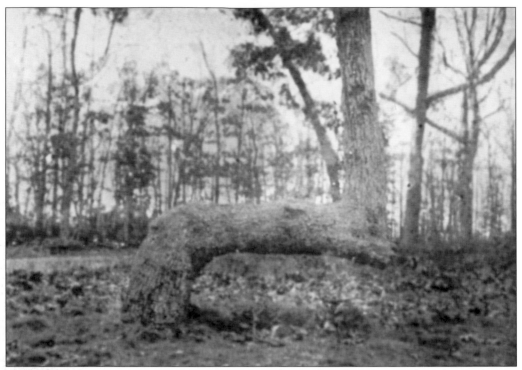

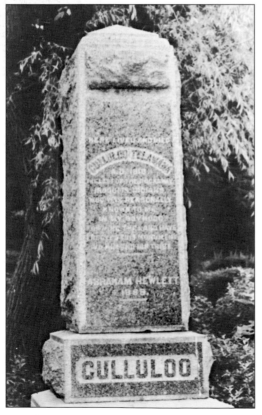

This trail marker tree stood on the south side of Broadway, near its intersection with Linden Street, until about 1900. Described as the last of a 100-foot circle of live oaks that formed the site of ancient Rockaway tribal council meetings, these trees and the banks of discarded shells that dot the surrounding coastline were the last visible reminders of the Rockaway tribe. (HWPL.)

Culluloo Telawana, believed to be the last of the Rockaway Indians, died in 1818. A monument was erected by his friend Abraham Hewlett in 1888 and located on Broadway near Linden Street in Woodmere near the site of Culluloo's hut. During later development of the area, it was moved to its current Woodsburgh location. Modern historians question whether Culluloo was Native American or an escaped slave, but no one questions Hewlett's sentiment. (HWPL.)

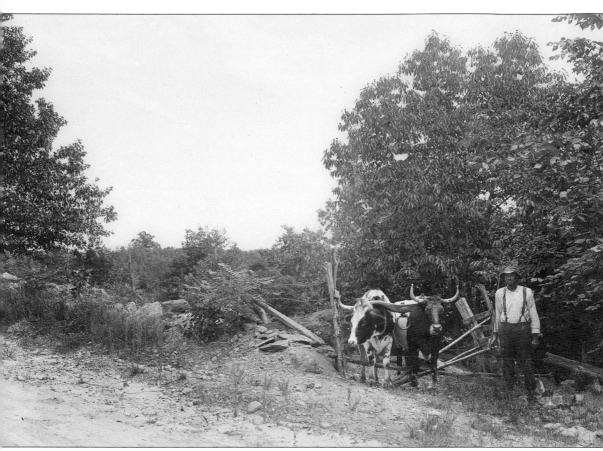

Just after sunrise, the cowkeeper would blow his horn and the farmers would send out their cows. He would then take the cows to this communal pasture and return them to their owners before sundown. George Hewlett was Hempstead's cowkeeper during the mid-17th century. For about 50 years after the founding of the town of Hempstead, the area called The Rockaways remained undeveloped cow pasture. By 1906, when this unidentified farmer was photographed by Wallace Small, encroachment by the railroad and land developers was already changing the scenic countryside. (HWPL.)

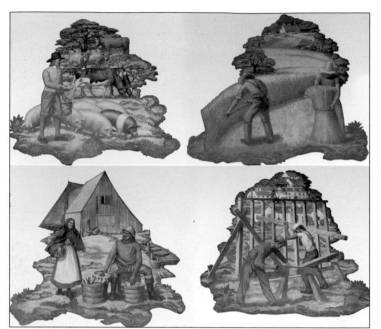

By 1700, there was a small settlement in the area of today's East Rockaway and a farm settlement on the present Rockaway Peninsula. Since the area was known as "The Rockaways," their respective distances from Hempstead village caused them to be known as Near Rockaway and Far Rockaway. In 1939, WPA artist Victor White of Cedarhurst depicted the life of earlier Long Islanders in a series of murals for the Rockville Centre post office. (Photographs by Philip Vollono.)

The first Hewlett homestead, built by George Hewlett, was on today's East Rockaway Road. Overlooking the "vly," or marsh, it was known as the "House at the Head of the Vly." In 1749, when the original homestead became outmoded, the Dutch Colonial house shown above was acquired and moved to its present location on East Rockaway Road. The home remained in the Hewlett family until 1984. Almost 300 years after his death, Hewlett's Point and George's Creek still bear the name of their first settler. (HWPL.)

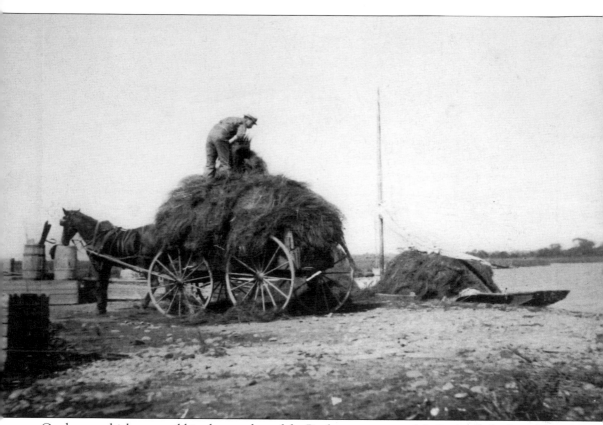

Cordgrass, which grew wild in the marshes of the Rockaways, was used for livestock feed, mulch, mattress stuffing, papermaking, and insulation. As early as 1667, the town of Hempstead imposed fines on anyone cutting salt hay in the common meadows before July 25, the official date of "marshing season." By 1860, the first Monday in September was the day to stake a claim on public land, with harvesting beginning the following day. Collected with a scythe or a horse-powered mowing machine, up to three tons of hay could be reaped from an acre of salt meadow. After drying, it was loaded onto a scow, heaped into a stack, and towed by boat for transport to markets like Brooklyn's Bushwick Hay Market. (Frederick W. Kost; Post-Morrow Foundation.)

In 1767, a few miles south of the Hewlett homestead, Josiah Martin (1699–1778) purchased 600 acres of land from John Cornell, a descendant of Richard Cornwall. Martin, a wealthy planter from Antigua, commissioned architect Timothy Clowes (b. 1724) to design a manor house. It contained eight large rooms and was, by all accounts, lavishly appointed and surrounded by orchards, woods, ponds, and outbuildings, including slave quarters. (LC-PPD.)

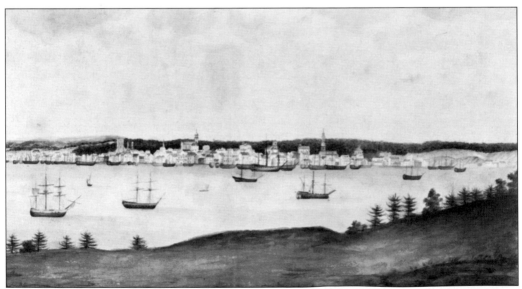

During the American Revolution, most of the population of Hempstead's south shore remained loyal to the Crown. Differences in political allegiance led to the formation, in 1784, of the separate towns of North Hempstead and South Hempstead. In 1801, the southern town became known as Hempstead and was part of Queens County. (*A View of the City of New York from Long Island.* Unattributed, *c.* 1770, LC-PPD.)

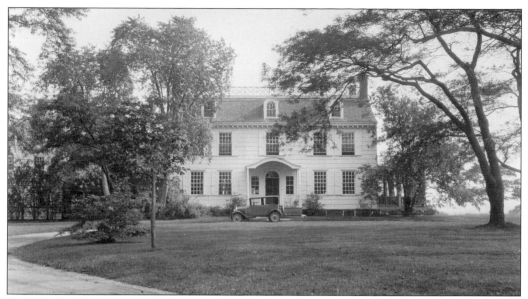

By 1817, the Martin property was known as Rock Hall. After Josiah Martin's death, the house passed to his son, Dr. Samuel Martin, a respected physician with Tory sympathies. By 1824, Dr. Martin's heirs had lost their fortunes, and industrious farmer Thomas Hewlett (1793–1841) bought the property at auction. (Photograph by D. Smith (1924); LC-PPD.)

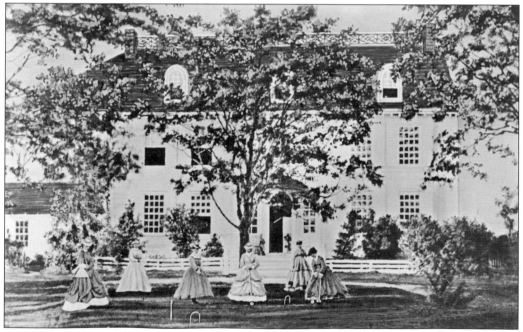

Several of the Martin family stayed as tenants on the property, which Thomas and Mary Hewlett and their family occupied and restored. Hewlett opened Rock Hall to paying guests during the summer, perhaps as early as 1828, as the Rockaways were already becoming a vacation destination. This Civil War–era view of Rock Hall is attributed to photographer Matthew Brady. (QL-LID.)

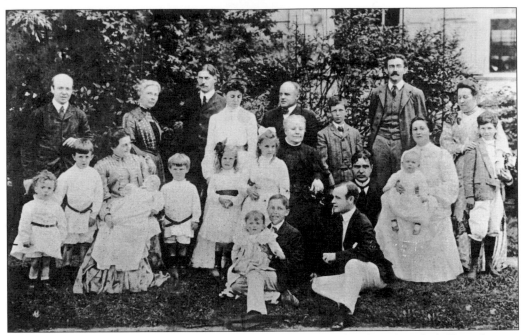

Pictured at a 1904 family gathering, architect James Monroe Hewlett (standing, far left) was born at Rock Hall in 1868. He spent summers there until 1904, when he moved his wife and 10 children to Martin's Lane, which he designed and built on the Rock Hall property. His firm, Lord and Hewlett, created mansions and public buildings throughout the metropolitan area. Hewlett's daughter, Anne, married the futurist architect R. Buckminster Fuller at Rock Hall in 1917. (Rock Hall Museum.)

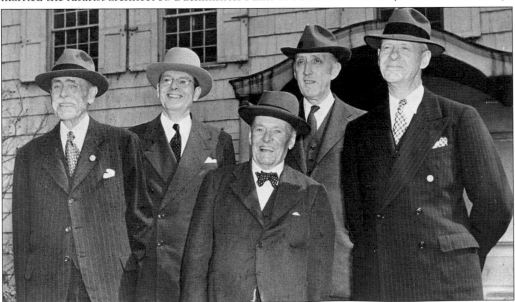

Rock Hall remained in the Hewlett family, who donated it to the town of Hempstead in 1948. In 1953, it opened as a museum affiliated with the town of Hempstead and the Society for the Preservation of Long Island Antiquities. Family members in this photo, from left to right, are Oliver T. Hewlett, Charles A. Hewlett, George Hewlett, Joseph S. Hewlett, and George W. Hewlett. (Photograph by Wendell Kilmer; NC-DPRM.)

Two

THE HEWLETTS

George Hewlett's family emigrated from England in 1636. Hewlett eventually settled in Hempstead, and held high positions in the town councils of the 1650s. The first Hewlett home was south of today's East Rockaway Road, overlooking the marsh (*vly* in Dutch) and was known as the "House at the Head of the Vly." Members of the large Hewlett family were the first major landholders in the area, and by the 19th century the area was known as Hewletts. The first railroad station was, for a few months in 1869, named Cedar Grove and for a few years in the 1890s was renamed Fenhurst. In 1897, Augustus Hewlett ensured the reinstatement of the family's name with a donation of land for a station to be known as Hewlett.

As the civic needs of residents changed, some chose to incorporate into separate villages. Hewlett Harbor (1925), Hewlett Neck (1927), and Hewlett Bay Park (1928) have their own village governments and local laws and provide many of their own services, while Hewlett remains unincorporated. The Hewlett-Woodmere School District, established in 1898, encompasses parts of The Hewletts, Woodmere, and Woodsburgh, as well as parts of Valley Stream and Lynbrook. From a one-room schoolhouse on Broadway, the district has grown substantially. Today the Franklin Early Childhood Center, Hewlett and Ogden Elementary Schools, Woodmere Middle School, and George W. Hewlett High School are consistently considered among the best in the state.

The beautiful landmark Trinity-St. John's Church was built in 1877. Its cemetery is a resting place for most of the early families of The Branch. The Church of St. Joseph serves the Roman Catholic Community, while four synagogues—Congregations Anshei Chesed, Beth Emeth, Toras Chaim, and Ahavat Yisrael—are located in the community, as is the Stella K. Abraham School, a yeshiva high school for girls.

Trinity Church Hewlett, Long Island, N. Y.

Thomas Hewlett wrote in the 1820s that it took his family more than two hours in a horse and buggy to drive the 10 miles to St. George's Episcopal Church in Hempstead for services. For a while, local Episcopalians alternated Sunday services with their Presbyterian neighbors in a donated blockhouse by the beach. In 1835, it was decided that St. George's would establish a mission in the area, to be named Trinity Church, Rockaway. The Van Wyck family donated land on Broadway in Hewlett, and the chapel's cornerstone was laid in 1836. Seven years later the congregation separated from St. George's and became an independent parish. The growth of the parish resulted in the 1877 neo-Gothic structure that stands today. Abram Johnson, a builder by trade and vestryman of the church, submitted the winning construction bid and the cornerstone was laid in July of that year. Samuel Wood donated $1,500 for the purchase of an organ.

The Long Island Rail Road (LIRR) was established in 1834 to create a route across Long Island. Trains shortened a three-day trip between Long Island City and Greenport to a mere five hours. In October 1867, the South Side Railroad began its route from Jamaica to Babylon. As one of several competing rail and trolley lines to the Rockaways, the South Side expanded its service and in 1869 established the Rockaway Branch. (Village of Lawrence.)

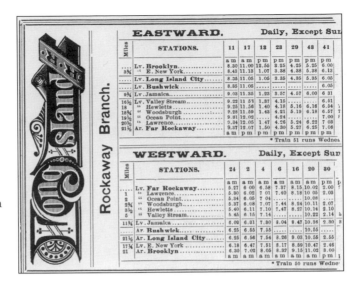

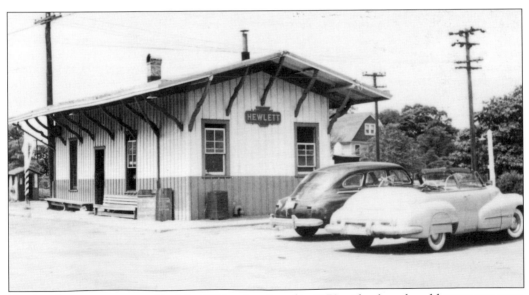

Hewlett Station was erected in July 1869 and replaced in 1870 with a board-and-batten structure that, though renovated, still stands today. It is regarded as the oldest station building on today's Long Island Rail Road and the only one erected by a LIRR predecessor. In 1893, the railroad changed the station's name to Fenhurst, *fen* being a term for a swamp or wetland. The population of the area commonly known as The Hewletts was not pleased with the change. In 1897, Augustus J. Hewlett deeded property to the railroad on the condition that it be renamed Hewlett. (HWPL.)

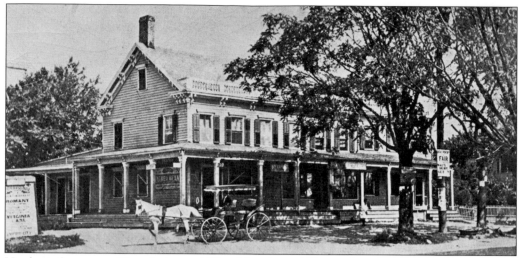

Hewlett's first post office, designated Woodsburgh in 1873, was located in the general store on the corner of Broadway at Franklin Avenue. Built before 1870 by the Hewlett family, it was a stagecoach stop on the route between Far Rockaway and Jamaica and was at one time the only commercial building between Jennings Corner and Near Rockaway. (HWPL.)

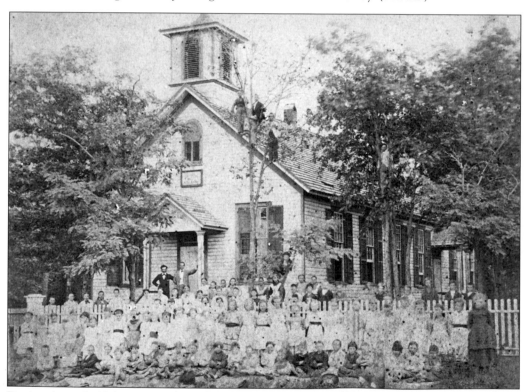

During the early 19th century, the only local schools were in Valley Stream and North West Point (Inwood). When the first schoolhouse was built in The Hewletts, it was located on Broadway near East Rockaway Road. This faded photograph from 1878 shows the principal, a Mr. Peck, and assistant principal, a Mr. Vandervoort, on the porch surrounded by students and teachers. (Hewlett-Woodmere School District.)

After the Civil War, the Grant Park neighborhood was created, its streets named for Union generals. The emerging area, shown in this 1906 map, included sand and gravel quarries as well as small farms, pastures, and roadside inns. Developments like the Sunbury homes, built in the 1930s by the Gibson Corporation, soon replaced the farms. A county park, named Grant Park, was established nearby in 1955. (HWPL.)

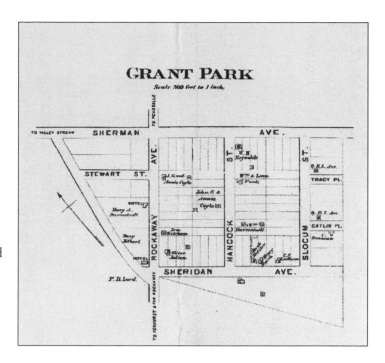

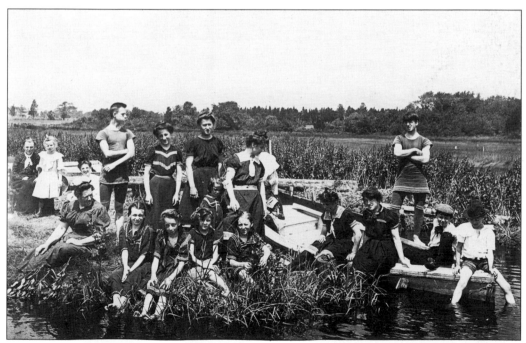

The waterways of The Branch provided vacationers with opportunities for exploration and communing with nature. Many species of water birds thrived in the lush wetlands. Contemporary chroniclers praised the inlet's gentle waters, the meadows of colorful flowers, and adjacent fruit orchards filled with songbirds. A picnic lunch would make the day complete, as visitors would be ferried to the Old Swimming Hole (shown here c. 1906), near East Broadway in Hewlett, for an afternoon in the country. (HWPL.)

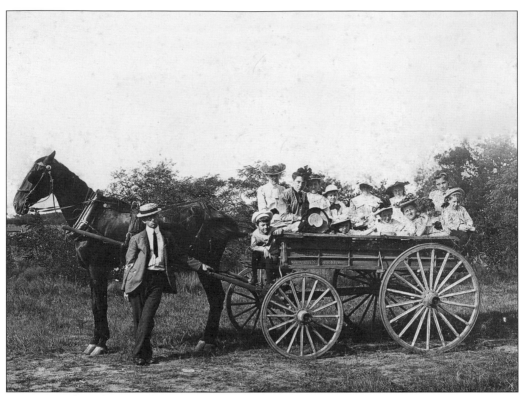

It was not unusual for families to travel from Manhattan or Brooklyn by horse-drawn wagon to visit their country cousins. This wagon's lettering identifies it as the property of E. Z. Small of Lorimer Street in Brooklyn. Several members of the Small family belonged to the Hewlett Fire Department when this *c.* 1906 photograph was taken, probably by Wallace Small. (HWPL.)

Keystone Yacht Club was established in 1888 as a family-oriented club dedicated to boating and waterfront activities. Members have shared their knowledge, abilities, and talents in the direct management and maintenance of the club. When the original schoolhouse on Broadway was replaced, the building was acquired by the yacht club and moved to its bay property for use as a clubhouse. (QL-LID.)

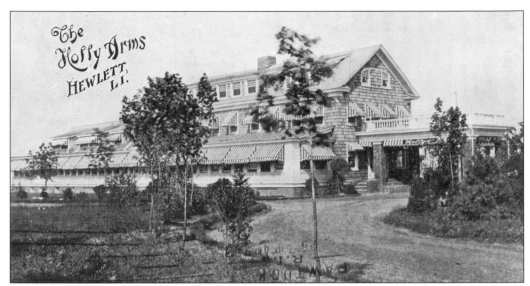

A hostelry since the 18th century, this building was originally a farmhouse owned by the Hewletts. In 1890, Frank and Margaret Holly opened the Holly Arms Hotel at the intersection of Broadway and West Broadway, enlarging the building around the colonial structure. With a dining room that seated 1,000, it was at one time the largest transient resort hotel on Long Island, attracting such notables as Theodore Roosevelt, Lillian Russell, and Diamond Jim Brady. The Holly Arms burned down in 1926. (HWPL.)

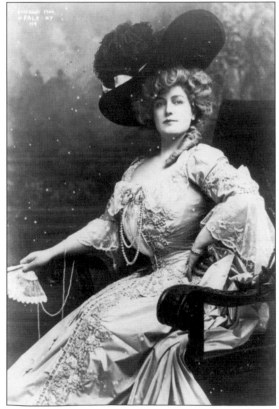

Lillian Russell (1861–1922) married four times and had an international career that included opera, burlesque, and vaudeville. In 1893, Russell commanded a salary of $700 a week plus half the gate proceeds. The "Queen of Comic Opera" spent many summers in The Branch, where she caused a sensation riding her bicycle down Broadway to the Holly Arms. Engineers reportedly sounded the train whistle all down the line when Russell was aboard. (LC-PPD.)

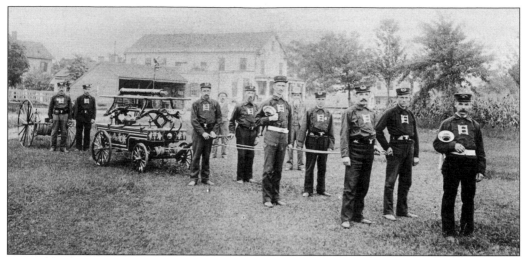

A September 1891 meeting in the home of Henry Werner Jr. established the Hewletts Engine Company. Members moved a donated truck house to property on Franklin Avenue that William Longworth leased to the engine company for $1 a year. A hand pumper and hose cart were purchased in 1892. In 1904, Hewlett Engine consolidated with Hewlett Volunteer Hose Company No. 2 as the Hewlett Fire Department. This 1893 photograph (above) shows, from left to right, Fred Muller, Isaac Meyer, Henry Longworth, Frank H. Weyant, Thomas Cheshire, George T. Hewlett, Charles Small, Fred Horton, George Muller, and Lorenzo Small. Below is the 1852 Rumsey hand-pumper before its 1986 restoration. It was purchased by Engine Company No. 1 in 1892 and served until 1916. (Above, HWPL; below, Hewlett Fire Department.)

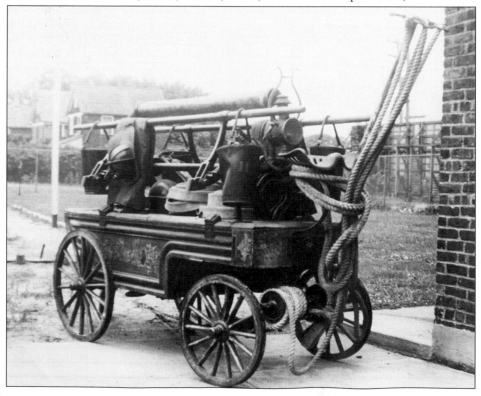

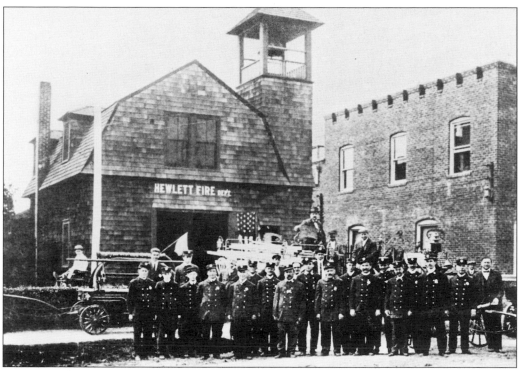

In January 1905, Divine and Elizabeth Hewlett donated property on Franklin Avenue for a firehouse in honor of Augustus Hewlett, a fireman for many years. In 1916, an American LaFrance motor pumper (below)—the first motor-driven fire apparatus in The Branch—was purchased to replace the outdated equipment shown in the above 1912 photograph. It served until 1948, and as a tournament truck, broke the New York state record in 1947. (Above, HWPL; below, Hewlett Fire Department.)

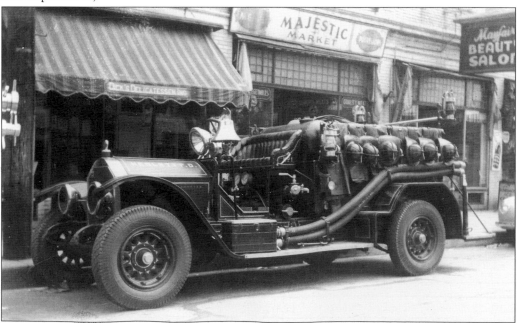

The Hewlett Fire Department Annex, seen in this 1923 photograph by Eugene Armbruster, was on the south side of Broadway, northeast of Hewlett village, near today's Grant Park. Located in a less populated area of town, it had a fire bell to raise the alarm and was used to store equipment, which could be quickly brought to the scene of a fire. (QBL-LID.)

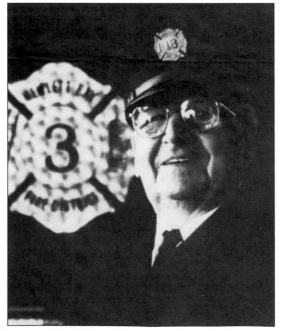

When Pasquale "Patsy" Plantamura came to Hewlett in 1915, he opened his barbershop in Hewlett's one-block business district. Patsy joined the fire department in 1921 and was a member until his death in 1990 at the age of 107. Celebrated as the nation's oldest active volunteer fire fighter, he was cited in the *Guinness Book of World Records* and appeared on the *Today Show* and *Good Morning America*. (Hewlett Fire Department.)

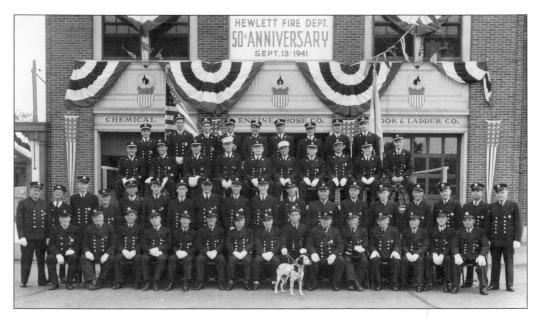

The photographs on this page commemorate the 50th anniversary in 1941 of the founding of the Hewlett Fire Department. Shown in front of the 1925 fire house on Franklin Avenue are the members of the department (above) and the Ladies Auxiliary (below), which was founded in 1940. The Ladies Auxiliary has had an active role in supporting the firefighting community and charity fundraising. Members shown are, from left to right, (first row) Lucy Dilg, Mabel Provenzano, Ella Hendrickson, Anna Seaman, Mary Kearns, Hannah Leonardi, Phyllis Coburn, Marion Jackson, Clarice Adams, Frances Zara, Eleanor Chimato, Millie Resney, and Martha Metzler; (second row) Elsie Hicks, Mabel Cassella, Esther Tetlemer, Zena Provenzano, Lil Bleich, Edith Petrillo, Helen Hagendown, and Maureen DeGallo. (Hewlett Fire Department.)

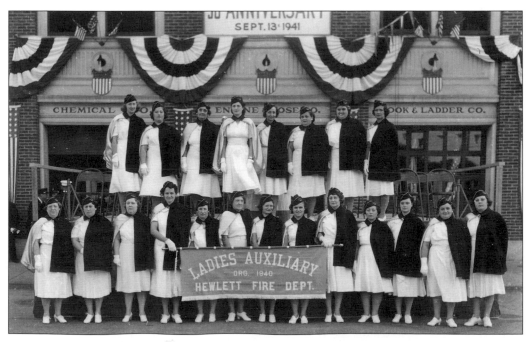

The first Roman Catholic services in The Branch were conducted in Daniel Longworth's parlor in Hewlett. Many early members of the Roman Catholic community were Irish and Italian immigrants who worked as servants on the nearby estates. When the front porch could no longer accommodate the congregants, Longworth donated land on Broadway on which the first St. Joseph's Church was built. (Robert Longworth.)

Many of the parishioners of St. Joseph's were recent immigrants who worked as cooks, maids, gardeners, and chauffeurs. Social events such as church picnics not only provided much-needed recreation but helped to form an important anchor in the new community. St. Joseph's School opened in 1957 with 170 students; by 1958, its enrollment had doubled. (HWPL.)

Fr. Arthur Dorris (d. 1875) was the first priest of the new congregation. The first St. Joseph's church building (right) was a small wooden structure located on the east side of Broadway between Ives Road and Piermont Avenue. By 1917, the congregation of about 200 parishioners was outgrowing the structure, which had been restored after fire damaged it in 1916. Fundraising efforts during the 1920s resulted in a new building in the Spanish Romanesque style. Mass was first celebrated at the new St. Joseph's Church (below) on March 19, 1931. The old wooden church stood until it was destroyed by fire in the 1940s. Demolition of the old church building signaled an expansion in the Hewlett business district, as new stores were built farther east on Broadway. (Above, QL-LID; below, HWPL.)

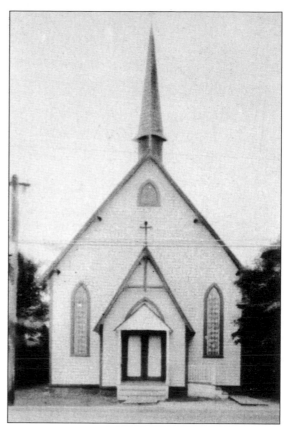

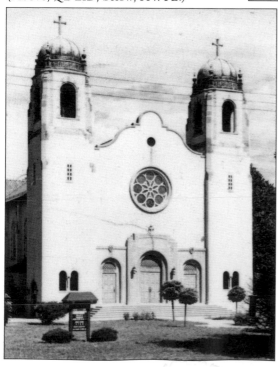

Since paved roads were not common until the 1920s, horse carts were still widely used in the area. For commercial deliveries as well as general transportation, horses and wagons remained an important part of life in the area until the early 1940s. These fellows are pictured on East Broadway in Hewlett around 1910. Apartments stand on the property once owned by the John Dilg family. (HWPL.)

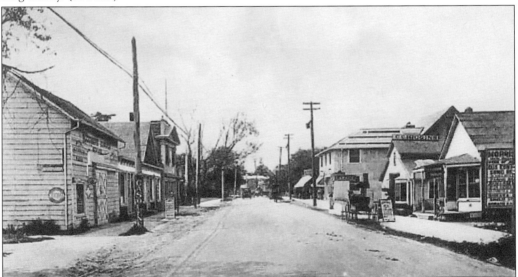

When this photograph was taken around 1915, Hewlett and Woodmere were just beginning to develop business districts. Small homes and the occasional harness maker or blacksmith shop punctuated Broadway looking down the road to Longworth's dairy farm, Trinity Church, and beyond to Woodmere. (Emily Domanico.)

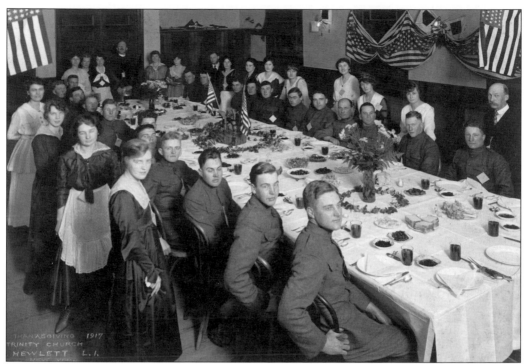

During the first World War, the community was a hub of patriotic activity. Many recruits went to boot camp at local facilities like Camp Upton in Yaphank and Camp Mills in Mineola before shipping out to France. The hospitality of The Branch was one more thing to be thankful for, as these doughboys celebrate Thanksgiving 1917 in the basement of Trinity Church. (QL-LID.)

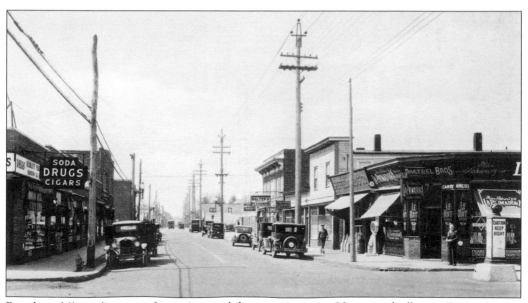

Broadway follows the route of an Indian trail that stretched from Hempstead village to Far Rockaway. The site of an early stagecoach stop, the intersection of Broadway and Franklin Avenues has been the business center of Hewlett village since its founding. (Author's collection.)

George and Jane Kohler's Metropole Café was located on the southeast corner of Broadway and Franklin Avenue. Although the original building has been extensively remodeled to accommodate many shops over the years, there has been a restaurant on this site since the 1920s. Local residents will remember it as the Hewlett Inn, Rafters, Matty K's, Shackletons, Liga, and, most recently, Da Nicola. (HWPL.)

Originally located on Walsh and Brower Avenues in Woodmere, the Hewlett Embroidery Works was one of the few factories in The Branch. The business operated between 1911 and 1926. In this crenellated building on Broadway and Railroad Avenue, workers produced lace and a delicate, machine-made white-on-white style of stitchery called Swiss embroidery. (Barbara Gribbon.)

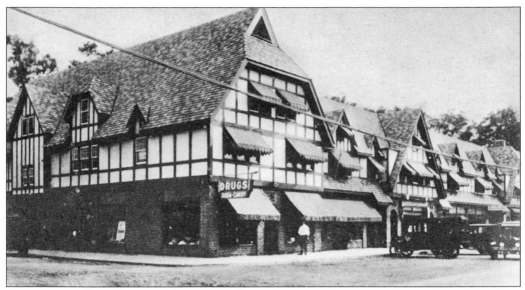

Prior to a recent renovation, the Tudor-style residential and commercial complex at Broadway and Princeton Avenue had changed little since its construction in 1926. This neighborhood was known locally as Hewlett Centre, to distinguish it from Hewlett village. Generations of shopkeepers and neighboring apartment dwellers have prized the location for its quaint exterior and central location. (QL-LID.)

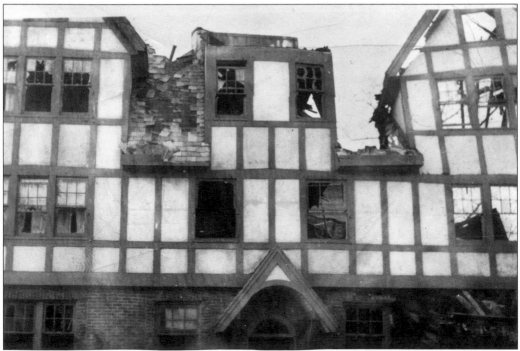

A similar building on East Rockaway Road was destroyed by fire in January 1939, forcing the 30 families who lived there to flee into the icy night. Firefighters recall that a cache of golf balls, stored in the basement for a neighboring driving range, became airborne projectiles as the heat increased, making it even more difficult to combat the blaze. (Robert Longworth.)

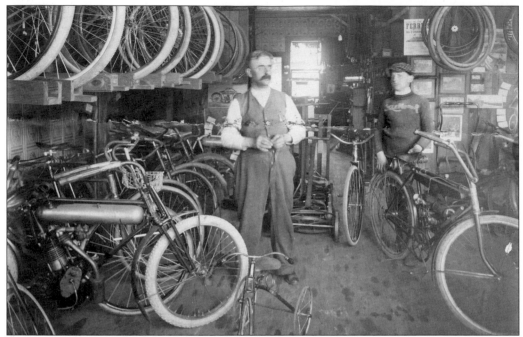

Cycling was a popular Long Island pastime. By 1898, the League of American Wheelmen had more than 102,000 members, including the Wright Brothers, Diamond Jim Brady, and John D. Rockefeller. Many clubs admitted both men and women to their meeting halls, where dining and drinking were almost as important as cycling. An 1895 article in the *Brooklyn Daily Eagle* details a group's ride to Patchogue. Among the names listed is Fred Ward (above at left in his shop). In 1910, the family lived on Broadway in Hewlett, near Fred's automobile and bicycle repair shop (below). Their eldest son, also Frederick, is probably the younger man in these pictures. After his marriage, he was employed as a chauffeur in Lawrence and later had a service station in Hewlett. (HWPL.)

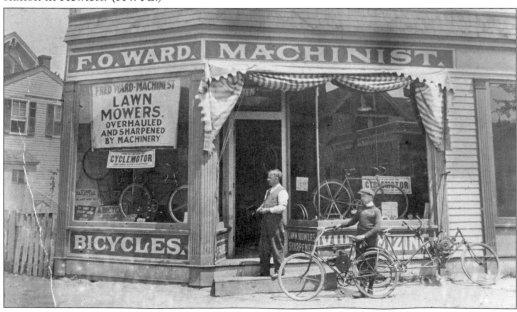

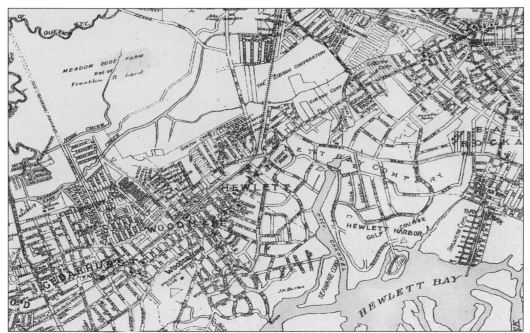

The incorporation of Lawrence, Cedarhurst, Woodsburgh, Hewlett Harbor, Hewlett Neck, and Hewlett Bay Park meant that these communities could make decisions involving zoning and services on a local level. These home rule powers are granted by New York state's constitution and define the legislature of a village as the mayor and board of trustees. Hewlett, Woodmere, and Inwood remain unincorporated communities, referred to as hamlets and dependent on the town and county to provide services. (HWPL.)

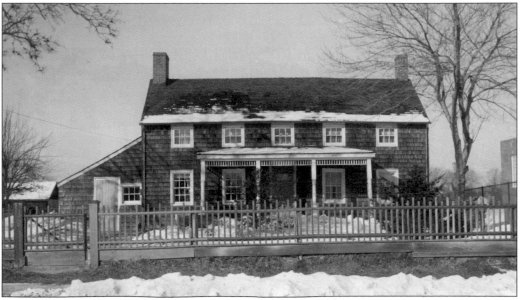

Melford Osker, a carpenter, and his sister, Katie, lived in this charming Colonial-style farmhouse on Broadway in Hewlett during the first quarter of the 20th century. It stood just south of the Hewlett Elementary School (visible on the right of the picture) until it was demolished to make way for the school's playground. (Photograph by Max Hubacher; HWPL.)

Since the Hewlett Elementary School was built in 1929, ...tions of s... ...dents have passed through its imposing columns. The school was enlarged in 1949, and further expansion and renovation took place in 1993. (Photograph by Max Hubacher; HWPL.)

In 1928, Richard Lennox opened the Lennox House shop in a 12-foot by 18-foot cottage on the site of his grandfather's dairy farm. Lennox created his version of a general store and featured Early American reproduction furniture. Enhanced with rescued artifacts from the Oliver Hewlett homestead in East Rockaway (demolished in 1936), it grew into a charming complex of buildings and a mail-order business with over 100,000 customers per year. (HWPL.)

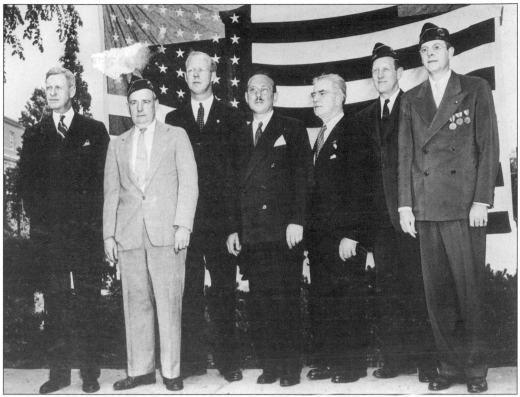

Between 1926 and 1997, the Woodmere-Hewlett Exchange Club existed as a service organization sponsored by the area's business and professional communities. In this 1942 photograph, from left to right, are George Hewlett, Chauncey Ogden, Gaylord Healy (president), Harry Pearlstein, Wallace Small, Rev. Leon Kofod, and Charles Hewlett. The national organization, founded in 1911, today promotes child abuse prevention and family services. (HWPL.)

The Hewlett Bay Company was the best known of a succession of corporations formed to build housing communities in the area. By "restricting" a community, the company could limit the zoning to only non-commercial, single-family dwellings built on at least five acres. "Restricted" also became a code word for excluding buyers of certain ethnic groups. (Author's collection.)

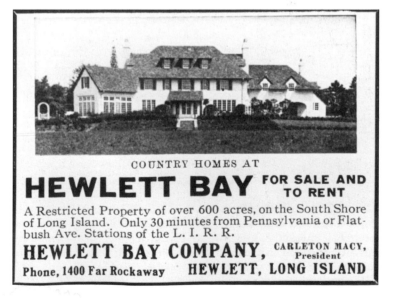

COUNTRY HOMES AT

HEWLETT BAY FOR SALE AND TO RENT

A Restricted Property of over 600 acres, on the South Shore of Long Island. Only 30 minutes from Pennsylvania or Flatbush Ave. Stations of the L. I. R. R.

HEWLETT BAY COMPANY, CARLETON MACY, President

Phone, 1400 Far Rockaway **HEWLETT, LONG ISLAND**

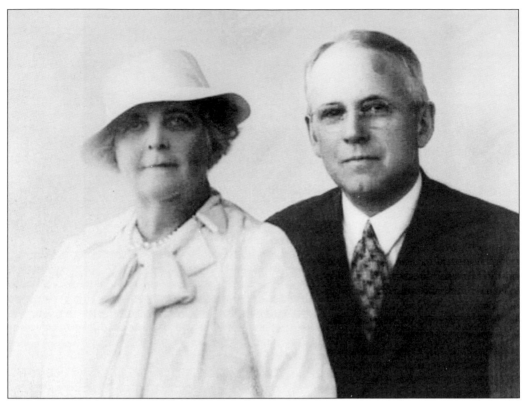

Carleton Macy (1872–1949), shown with wife Winifred, was an electrical engineer in the early days of the General Electric Company. Later in his career, he became an officer of Queensborough Gas and Electric and ran the company from 1903 until his retirement in 1927. During this time, he also was president of the Hewlett Bay Company and held official positions in several local banks and real estate development corporations. (Stephen Woodbridge.)

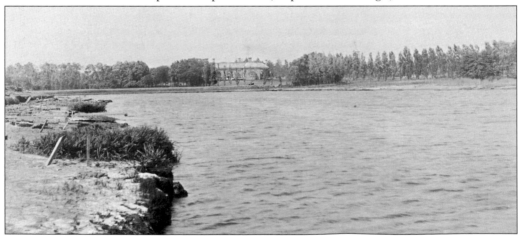

Wonderwhy, the home of Carleton Macy, was designed by the firm of Albro and Lindeberg and landscape architect Charles W. Leavitt Jr. It was located on the water at the foot of Piermont Avenue. The Hewlett Bay Company, after purchasing the land from the Hewlett family, dredged a deep channel that emptied into Woodmere Bay and, in so doing, turned a marsh into an exclusive residential community. (HWPL.)

Each of the original Hewlett Bay Park homes was built on a minimum of five acres. The 1920s saw further building in Hewlett Bay Park, though it still maintained a bucolic character. As the population grew, the need for utilities and better public services prompted local residents to incorporate in 1928. (Author's collection.)

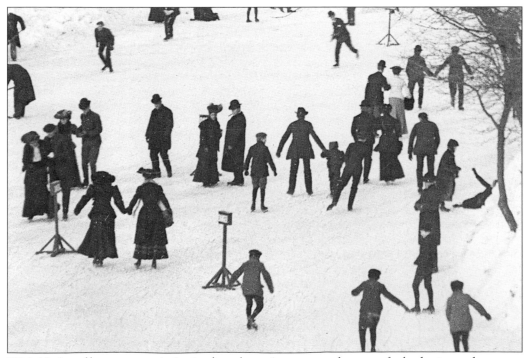

With blades of bone or metal, skating has always been a popular sport for both city and country residents, as seen in this c. 1906 photograph attributed to Wallace Small. Generations of children learned to skate on Willow Pond and Birch Pond in Hewlett Bay Park, Cedarhurst Park in Cedarhurst, or Sage Lake in Lawrence. Some residents even remember when it got so cold that even Woodmere Bay was frozen solid. (HWPL.)

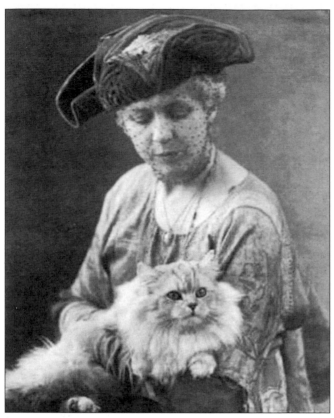

Carroll Macy, Carleton Macy's sister, graduated from the Rye Female Seminary in 1889. She was an avid traveler and raised show cats. King Winter, her nine-times best-in-show winner, was a silver colored, 15-pound champion valued at $2,000 in 1915. King Winter received more press coverage in *The New York Times* than Macy, with articles describing his career as the most celebrated show cat of his generation. (Stephen Woodbridge.)

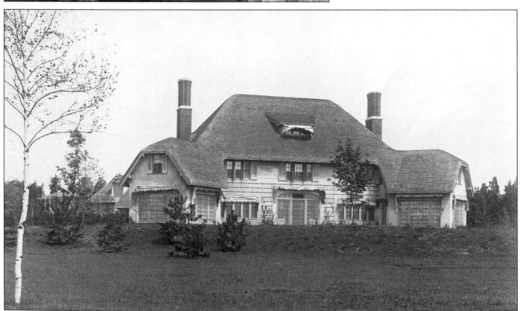

Birch Corners was built for Carroll Macy around 1907 by the firm of Albro and Lindeberg. The charming Cotswold-style cottage was located at the northwest corner of Cedar and Meadowview Avenues in Hewlett Bay Park. Records show that Birch Corners, like many of the neighboring homes, was leased to others when Macy summered elsewhere. She sold the property in 1920. (HWPL.)

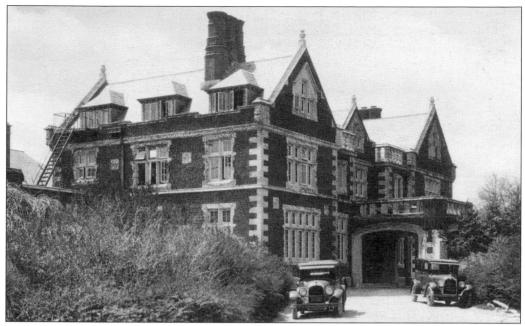

Henry Devereaux Whiton (c. 1870–1930) was president and treasurer of Union Sulfur Company and a benefactor of the New York Zoological Society. His home at Meadowview and Piermont Avenues was designed in 1911 by architect Alfred C. Bossom (1881–1965) in the style of an early Stuart manor house. From 1920 until its sale in 1992, the 9.5-acre estate was the site of the Lawrence Country Day School. (Author's collection.)

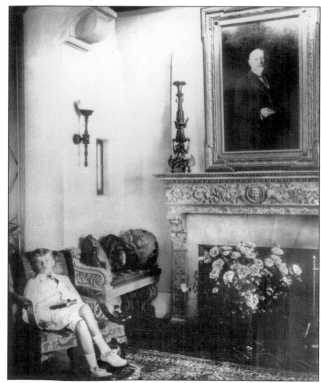

At his childhood home, Whiton House, Herman Frasch Whiton (1904–1967) sits near a portrait of his grandfather and namesake, Herman Frasch. The elder Frasch was a chemist, inventor, and founder of United Sulfur Company. His process for separating sulfur from crude oil revolutionized the petroleum industry and made his fortune. Herman Whiton was later a Princeton graduate and won gold medals in yachting during the Olympics in 1948 and 1952. (HWPL.)

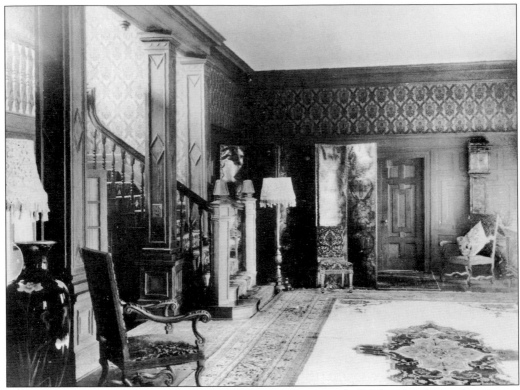

The carved oak railings and paneling of Whiton House's entry hall (above) welcomed visitors to the grand home. Like most Hewlett Bay Park residents, the Whiton family furnished their home in high style. A comfortable environment for entertaining and for rare specimens to flourish year-round, the conservatory (below) was a fashionable addition to Victorian and Edwardian homes on both sides of the Atlantic. (HWPL.)

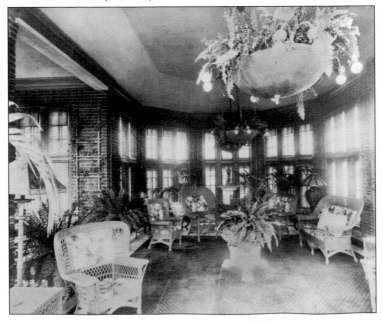

Everit Avenue, Hewlett Bay Park, named for V. Everit Macy, would eventually contain some of the most prestigious houses in the area. The road winds through Hewlett Bay Park, past the former site of the steeplechase grounds, around Willow Pond, and turns onto a quiet two-mile, tree-lined lane. Though homes now line the street, it retains its rural ambiance. (HWPL.)

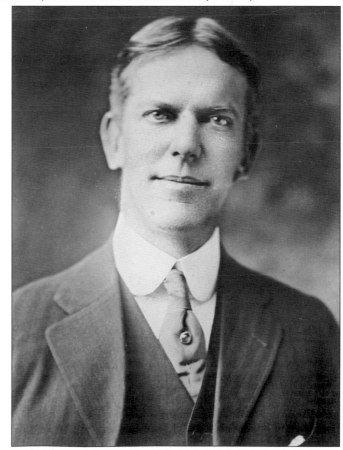

Valentine Everit Macy (1871–1930) was one of the Hewlett Bay Company's investors and had a home in Hewlett Bay Park. Macy, a banker and amateur archaeologist, was a benefactor and trustee of the Metropolitan Museum of Art. He held a series of elected offices in the government of Westchester County, where a park is named in his honor. (LC-PPD.)

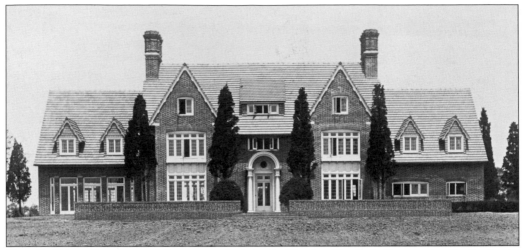

Twin Gables, a Georgian style home, was built by the Hewlett Bay Park Corporation for Benjamin Lissberger (1875–1937), a metallurgist and financier. Located off East Rockaway Road near Waverly Avenue, it stood on nine acres and had 19 rooms and five baths. It was assessed at $100,000 at its sale in 1941, when the average cost for a new home was about $4,000. (HWPL.)

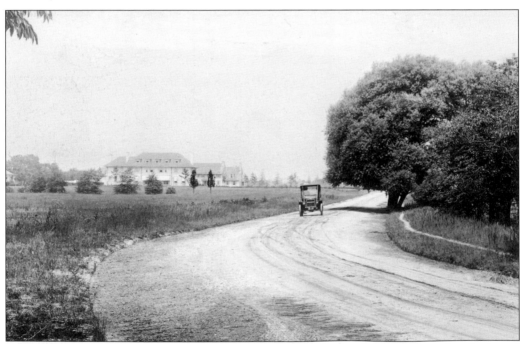

Joseph S. Auerbach (1855–1944) was the attorney for the Hewlett Bay Company. Auerbach and his partner, Robert Stevenson, purchased over 600 acres from the Hewlett family, which Auerbach eventually sold to the Hewlett Bay Company. The land was developed with the stipulation that each home occupy at least five acres. At his death in 1944, Auerbach had acquired over 2,000 acres in Hewlett Harbor. (HWPL.)

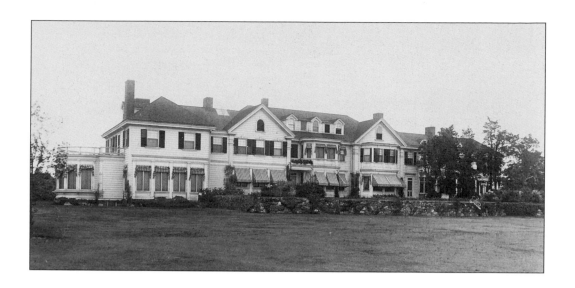

When the builders broke ground for Joseph Auerbach's summer residence, they uncovered the remains of an Algonquin Indian chief. He was buried with the wampum beads called "sewan." Auerbach commemorated the event by naming his home (above) *Seawane*. After Auerbach's death, the residence became the clubhouse for the Seawane Country Club (below), which was built on his property. As Auerbach's property was sold, the land surrounding his home was developed for housing. The village of Hewlett Harbor was incorporated in 1925. (Above, HWPL; below, Village of Hewlett Harbor.)

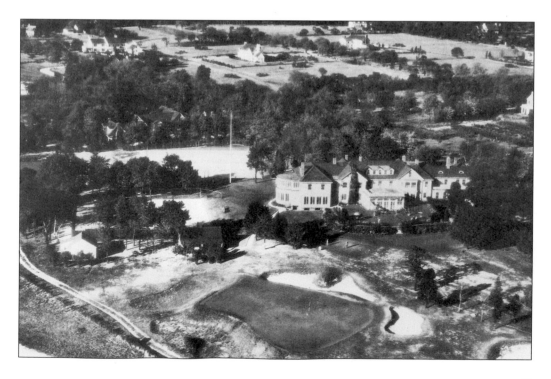

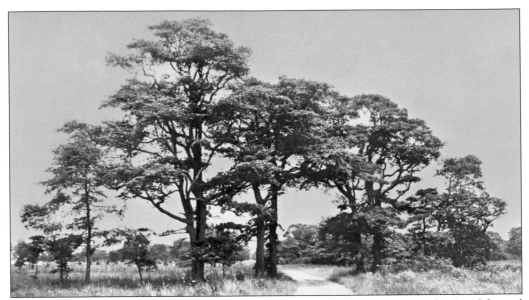

Named for the grove of pepperidge trees (*Nyssa sylvatica*) shown here, Pepperidge Road formed part of the southeast boundary of Hewlett Bay Company's holdings and was one of the last areas to be developed. To the southwest was the estate of Joseph Auerbach, which eventually became the Seawane Golf Club. (HWPL.)

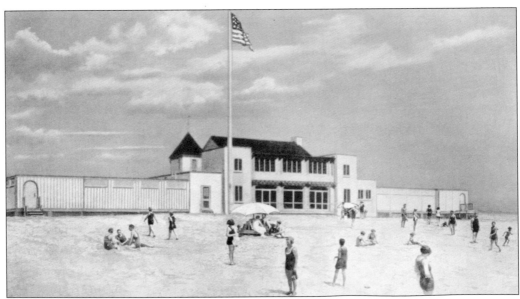

Mobster Arnold Rothstein is credited with turning organized crime into a corporate structure. Rothstein was the model for the characters Meyer Wolfsheim in *The Great Gatsby* and Nathan Detroit in *Guys and Dolls*. In 1916, he opened a casino in Hewlett Harbor, choosing to locate in Nassau because police protection was cheaper and the bettors placed larger wagers and were better losers than city gamblers. (Village of Hewlett Harbor.)

Three

WOODSBURGH, WOODMERE, AND WOODSBURGH AGAIN

As early as 1790, members of the Brower family had settled an area on Woodmere Bay that by the mid-19th century was known as Brower's Point. Samuel Wood, whose family came from the vicinity, was one of four brothers who owned a successful liquor distribution business in Brooklyn. The brothers made a pact: remain unmarried, keep their wealth within the family, and leave their estates to the last surviving brother, Samuel. After the Civil War, Samuel Wood purchased most of the farmland in Brower's Point with the intention of turning it into a fashionable resort named Woodsburgh. He built two hotels, the grand Woodsburgh Pavilion and the more moderate Neptune Hotel, and began to sell acreage for individual vacation cottages.

Upon Wood's death in 1878, his heir, his sister's son, Abraham Hewlett, challenged Wood's intent to fund a music academy in Brooklyn through his will. Hewlett and other investors formed the Woodsburgh Land Improvement Company, which eventually sold most of the land to Robert L. Burton, a New York industrialist and Rockaway Hunt Club member. From 1901 to 1909, Burton demolished or moved every building on the property and designed a planned community in the style of Garden City and Tuxedo, New York. Burton wanted to attract investors by providing homes, shops, recreational clubs, a post office, and modern utilities in a beautiful suburban setting.

The community attracted the population of businessmen and professionals that Burton had envisioned. The Morgenthau group continued to promote development of the area's facilities. The name Woodsburgh was temporarily lost when, in 1890, the name of the village was changed to Woodmere to avoid confusion with another municipality. The name was reestablished in 1912, when a portion of the hamlet incorporated as Woodsburgh. Several stables remained in the area until the 1940s, providing riding and equine boarding facilities. The Woodmere Club erected a state-of-the-art clubhouse in 1914 to augment its 18-hole golf course and tennis facilities. The Woodmere Methodist Episcopal Church, founded in 1871, built its current structure on Broadway in 1921. Congregation Sons of Israel, founded in 1934, was the first of several Woodmere synagogues.

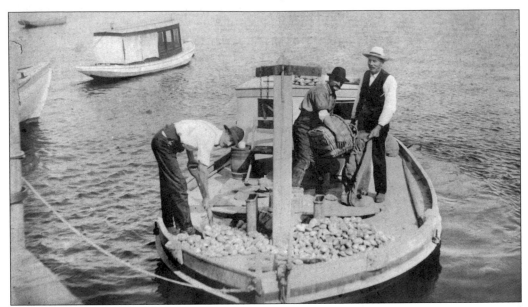

Many Branch residents proudly proclaimed themselves "clamdiggers." Though some clammers and oystermen had large sloops with dredges, most were family operations with small boats and large tongs. Jamaica Bay and Woodmere Bay were prized for "Rockaway" oysters, which were shipped to New York, Philadelphia, and as far as Europe. Baymen like Joe Combs, Hen "Fox" Brower, and Thomas Johnson (above, left to right) seeded leased oyster beds during the spring and harvested grown oysters in the fall. Their bay houses (below) provided shelter while they harvested clams and salt hay or went duck hunting, and were "vacation homes" during the mild season. Baymen might also increase their income by acting as hunting and fishing guides for the vacationing city folk. In 1882, the state estimated that the oyster harvest from the Rockaway District comprised 100,000 bushels a year. By 1917, 1,500 baymen were involved in clamming and oystering in Jamaica Bay. The industry disappeared in the 1920s, when increasing pollution caused the state to prohibit harvesting of shellfish in local waters. (James Pearsall Collection.)

During the Civil War, Thomas Johnson was a 17-year-old farm boy when he joined the First Regiment, Company B, New York Mounted Rifles. After re-enlisting, he served in Company E of the First Regiment New York's Provisional Cavalry. After the war he went home to The Branch to marry and become a bayman and carpenter like his father, Abram. Their property, today's Johnson Place in Woodmere, was located across Broadway from Trinity Church. (James Pearsall Collection.)

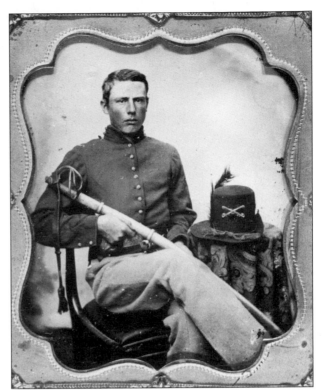

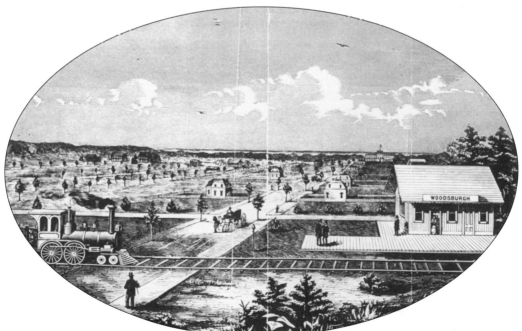

After the Civil War, the South Side Railroad expanded its service to include the resort areas of the Far Rockaway branch. The land for the depot was donated by Samuel Wood, who owned most of the surrounding acreage, known for generations as Browers' Point. Wood renamed the area Woodsburgh when the station was erected. (HWPL.)

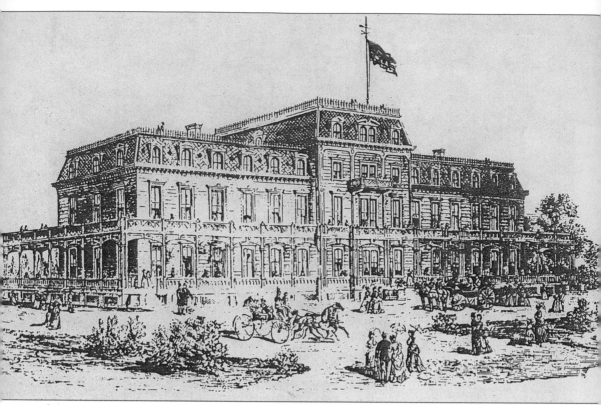

Liquor magnate Samuel Wood purchased the half-dozen farms at Brower's Point with the intention of developing the area as a resort town. In 1870, he opened the Woodsburgh Pavilion on Broadway at Woodsburgh Boulevard. The grand, three-story hotel had 80 rooms and could accommodate 150 guests. Wood's Pavilion and its sister hotel, The Neptune, comprised a resort that boasted cottages as well as luxury facilities. In addition to gaslit guest rooms on the top two floors, the ground floor housed a dining room and ladies' reception area, a wine room, reading room, doctor's office, clerk's office, and even a bowling alley. A steam yacht allowed guests to sail on Woodmere Bay. Within several years, other hotels opened, and the wealthy visitors they attracted established The Branch as a vacationer's playground. Wood was the last of four brothers, all of whom remained unmarried and made a pact to leave their fortunes to the last surviving brother. When Wood died in 1878, he left his estate to his sister's son, Abraham Hewlett. (HWPL.)

The English style of bathing allowed vacationers to maintain their modesty while enjoying the beach. Horse-drawn bathing machines transported fully clothed persons into the surf, where they changed into bathing attire inside the wagon. Assisted by "dippers," bathers then entered the surf, hidden from public view by the machine. Afterwards, horses were reattached to the machine and returned the clothed individual to the beach. (LC-PPD.)

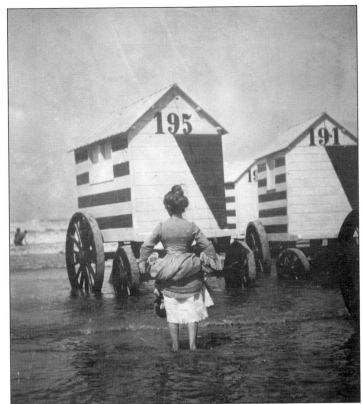

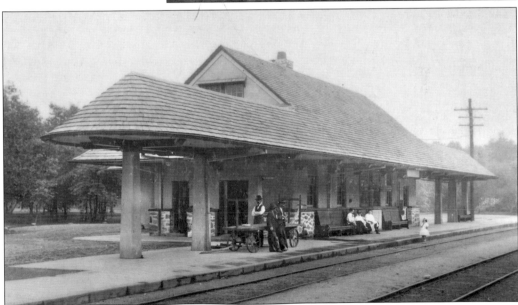

Woodsburgh was renamed Woodmere in 1899 to avoid confusion with Woodbury, another Long Island community. After Samuel Wood's death, the Woodmere Land Development Company, representing the Wood estate, sold the entire tract of land south of the railroad tracks—200 acres of woodland and 100 acres of marsh meadow—to Robert L. Burton for $125,000. Burton then purchased an additional 100 acres north of the tracks. (HWPL.)

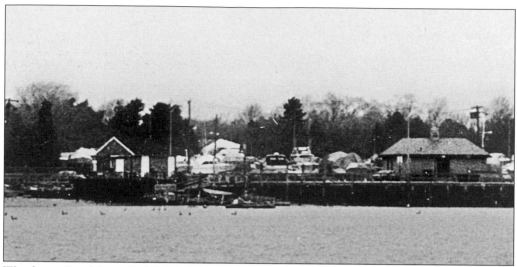

Woodmere Bay (also called Brosewere Bay) was the center of the economy for the area's shellfish industry. Many families built bay houses in addition to their homes in the village. Baymen often supplemented their incomes by renting boats and equipment to recreational fishermen, and they were experienced fishing and duck hunting guides. Phil Simon's fishing station (above) was a local landmark for decades. (NC-DPRM.)

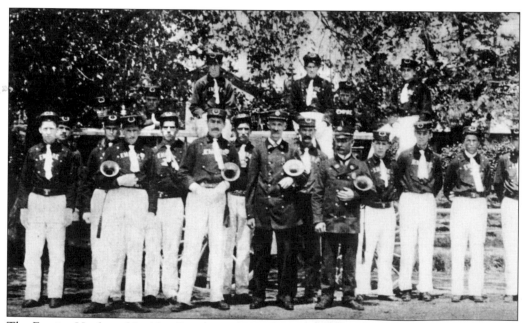

The Empire Hook and Ladder Company, shown here in 1905, and the Empire Hose Company shared firehouse facilities on Brower Avenue in the early 1900s. Along with the Woodmere Hose Company, they comprised the Woodmere Fire Department, a group of about 80 volunteers. Bellot wrote in 1917 that the companies' equipment included two chemical-hose engines, one horse-drawn apparatus, and one horse-drawn hook and ladder apparatus. (HWPL.)

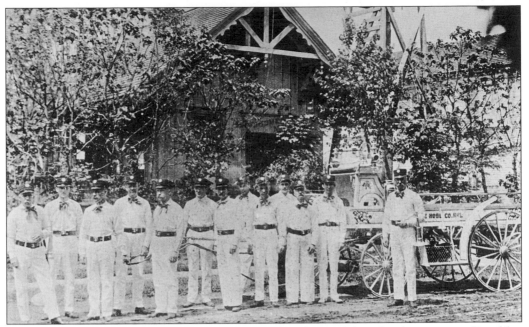

Members of the Woodmere Hose Company stand in front of their headquarters on Franklin Place. They are, from left to right, Charles A. Frost, C. A. Schiffmacher, William A. Juch, C. A. Schiffmacher Jr., Dr. E. C. Smith, A. Burtis, Edward Rich, Joseph Schiffmacher, William H. Latham, Edward L. Muller, and Warren Brower. (HWPL.)

Like churches, firehouses provided centers of social activities for the community. Woodmere Fire Department, pictured here in 1946, has participated in decades of parades and firemen's tournament celebrations. Equipped with large meeting halls, local firehouses were the venues for fundraisers, dances, and community suppers. Multiple generations of firefighters are represented in the membership rosters of all the local companies. (Dolores Combs.)

Like most of his family, Alanson Pearsall (born c. 1863) learned about life on the bay from an early age. In 1906, the Pearsalls posed with others in front of their home at 128 Combs Avenue, which stayed in the family until its demolition in 1966. They are, from left to right, Elsie, Evelyn, an unidentified friend, twins Fred and Frank (sitting), and Alanson, holding baby Helen. (James Pearsall Collection.)

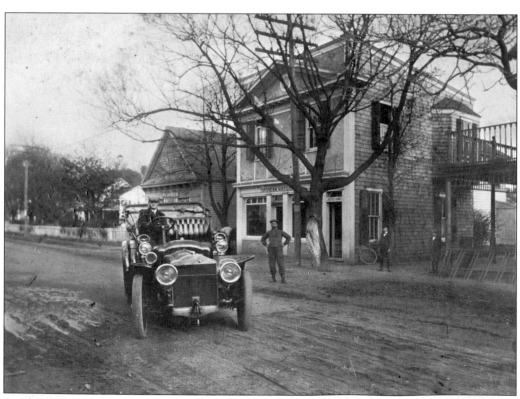

As this horseless carriage navigates a muddy Broadway in Woodmere, a curious pedestrian watches from the safety of the sidewalk. Buildings on the street include the plumber's shop and the structure housing both the harness maker and the justice court. The cupola of Woodmere School is visible in the distance. (HWPL.)

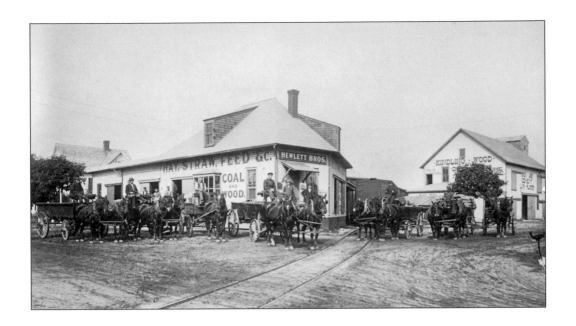

In 1902, brothers Whitfield and Divine Hewlett located their feed company (above left) at Railroad Avenue and Irving Place in Woodmere. The company originally distributed hay, chicken feed, and grain bought from the Pratt Food Company in Buffalo, New York. As business prospered, the Hewlett Brothers expanded their line of products to include apples from upstate New York, coal from Pennsylvania, potatoes from Long Island and Maine, lumber, building products, and Atlas Cement. In 1914, Hewlett Brothers lumberyard (above right) was the target of an attempted armed robbery, and a subsequent three-mile pursuit ensued. In 1915, Divine's son, Joseph Hewlett, and Joseph's uncle, Herbert, took over the thriving business. The buildings stood at this location (below) until the late 1960s when they were demolished for a shopping center. (HWPL.)

The Colonial Pharmacy, located at the corner of Irving Place and Broadway in Woodmere, was a local landmark and a great place to take your best girl for a soda! Married in 1898, owners William and Estelle Wisendanger were both pharmacists. Dr. William L. Walling had his dental offices on the second floor. In later years, the building became the office of Hewlett Oil Services. (Author's collection.)

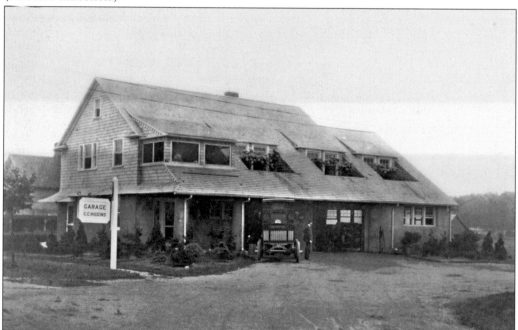

The Woodmere Land Company erected this building, which housed a 42-foot by 72-foot repair shop accommodating about 30 automobiles. It was located on Woodsburgh (later Woodmere) Boulevard near Railroad Avenue. By 1910, Charles C. Higgins (b. 1874) lived over the garage with his wife and son. Independent service stations were rare since most automobile dealers had their own service companies on-site. (HWPL.)

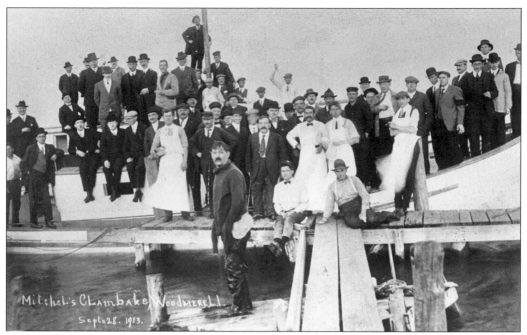

Summers in The Branch included entertainment such as horse races, strawberry festivals, oyster suppers, and, of course, clambakes. The staff at Mitchel's Clambake is shown here with some of their loyal customers and friends, *c.* 1913. (NC-DPRM.)

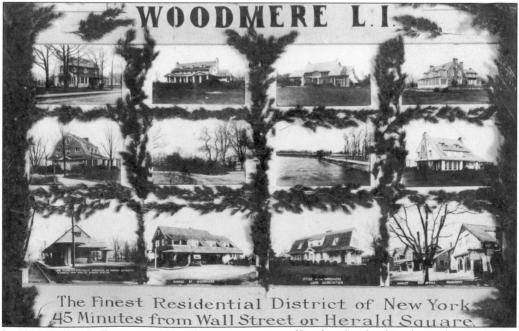

In 1901, Robert L. Burton purchased extensive tracts of land to develop his planned community, Woodmere. Burton tried to provide the residents with every amenity, including well-stocked shops, a country club, stables, a railroad depot, and a post office. Entangled in financial obligations, Burton sold his holdings to a syndicate headed by Maximilian Morgenthau in 1909. (Author's collection.)

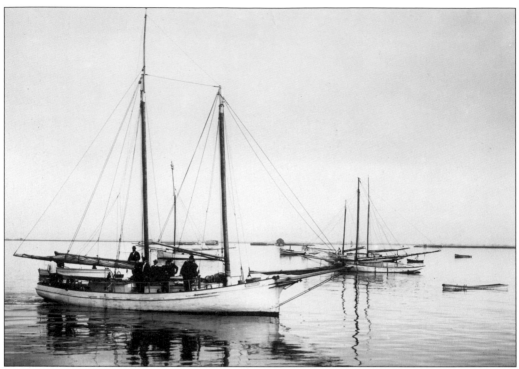

Many of the wealthier residents who summered at grand houses on the bay had their watercraft ferried from homes in Newport or Florida. Other vacationers rented fishing boats by the day. The *Sappho*, a gaff-rigged schooner, was probably used to take visitors on fishing excursions between 1890 and 1910. (HWPL.)

Edwardian adults dressed formally, and children were dressed fashionably to reflect well on the family. While children's clothing of earlier eras imitated that of their parents, it became more functional and less formal in the late 19th century. This little girl and her brother, photographed in Woodmere around 1900, were probably trying very hard to stay presentable while wishing they could find a tree to climb. (HWPL.)

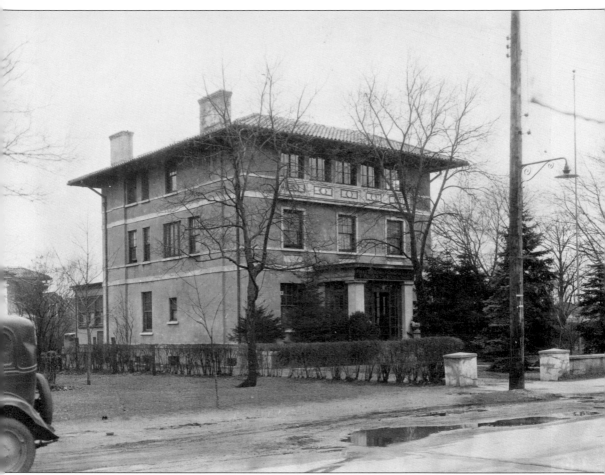

Before it served as the Fourth Precinct Police Station from 1928 until 1957, 126 Franklin Place in Woodmere had been a private home. It had an enclosed sunporch with wooden benches where officers would assemble for roll call. Those working the midnight shift had to stoke the coal furnace until a custodian came at 5:00 a.m. The three-story concrete structure served as the Five Towns Community House before it was demolished to make way for the driveway of the new Woodmere post office. In 1957, the precinct moved to its current location near Grant Park at Broadway and Sheridan Place. In addition to the incorporated and unincorporated Five Towns villages, the Fourth Precinct serves the populations of East Rockaway and Oceanside as well as Atlantic Beach, Lido Beach, and Point Lookout. (Nassau County Police Department Museum.)

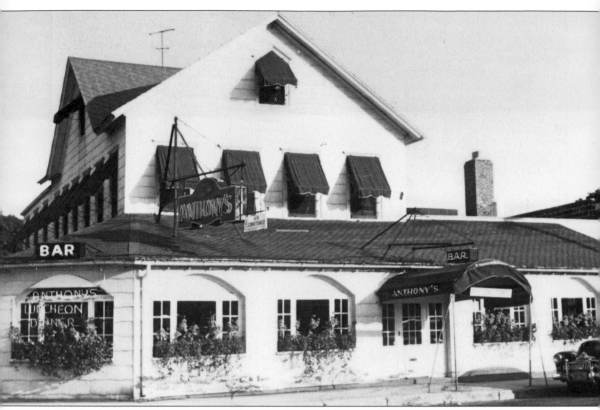

Charles Loon's Bay View Inn was a favorite place to dine as early as 1905. Located on the southwest corner of Broadway and Neptune Avenue, Anthony and Meta Fertitta purchased the Bay View Hotel from Arthur Harshiem around 1924 and opened it as Anthony's Restaurant. Known for its Italian specialties, seafood dinners, and lobsters, it became the meeting place for Woodmere-Hewlett Exchange Club as well as the location of Woodmere High School's senior dinners. Active until the mid-1950s, Mrs. Fertitta and son "Bunny" maintained Anthony's as a favorite spot for a fellow to take his best girl for a special date. (HWPL.)

When a post office was established in 1890, Woodsburgh's name was changed to Woodmere, to avoid confusion with another Long Island community. For many years, the local post office was in George Koch's drugstore on Broadway. A 1904 article describes how an early morning robbery resulted in the dynamiting of the post office safe and an exchange of gunfire between the robbers and Koch. (HWPL.)

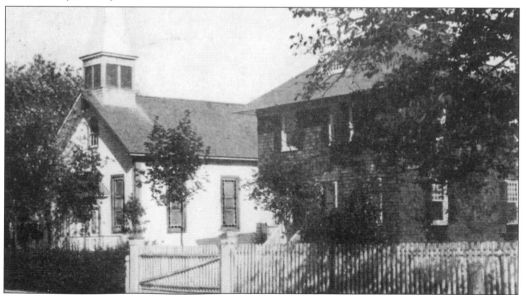

The building at 1023 Broadway, present home of the Woodmere-Lawrence United Methodist Church, was built in 1921, replacing an 1871 structure that was moved to the rear of the property. The 1898 parsonage to the right of the church later became its thrift shop. (Author's collection.)

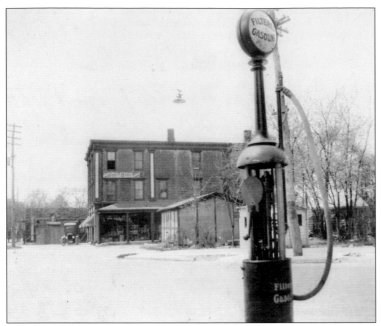

Warren D. Mott was the proprietor of the Wood's Neptune Hotel in 1873. In its glory days, the Neptune, located on the northwest side of Broadway, opposite today's Neptune Avenue, attracted an elite clientele. By the time of this 1923 photograph, the building had seen better days. Its sign advertises it as an upholstering and cabinetmaking establishment. (Photograph by Eugene Armbruster; QL-LID.)

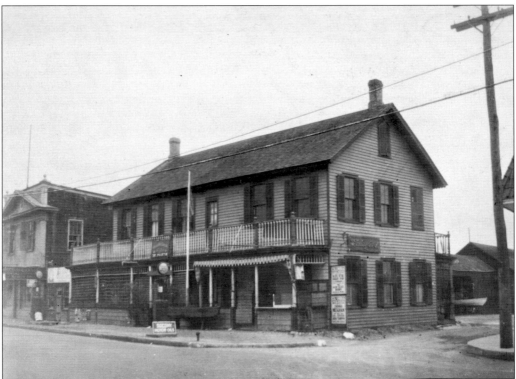

Martin's Broadway Central Hotel, located at Broadway and Conklin Street, Woodmere, was one of the smaller lodgings accommodating summer vacationers. Posters advertise films starring Thomas Meighan, a leading man in the silent-film era. Socony gas pumps in front of the hotel provide added convenience for the weekend motorist in a hurry. Historian and journalist Eugene Armbruster took this photograph in 1923. (QL-LID.)

In 1763, John Brower built Browers' Point Homestead, shown in this 1922 photograph by Eugene Armbruster. It remained in the Brower family until 1909, when it was sold to Charles R. Price. Built in the style typical of Dutch Colonial homes, the house has been renovated over the years but is still recognizable at its original location on East Broadway near Brower Avenue. (QL-LID.)

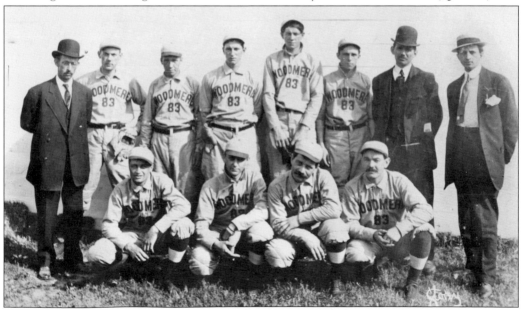

Alexander Cartwright published the first rules of baseball for the New York Knickerbockers in 1845. The game quickly caught on and local teams played the game in community fields all over the country. Woodmere's team is shown in this photograph, perhaps pondering an anticipated match with their Cedarhurst rivals in the early 1900s. (James Pearsall Collection.)

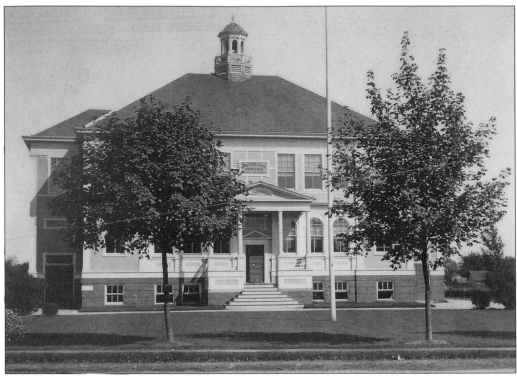

The Woodmere School (above) was built in 1898 to replace a one-room schoolhouse on Broadway. When the school caught fire on September 15, 1916, the combined efforts of the Hewlett, Woodmere, and Lawrence-Cedarhurst fire departments could not extinguish the blaze. As a result, its 300 students of all ages attended classes in stores, firehouses, and fraternal halls until a new building was constructed. (HWPL.)

Construction was begun on the new Woodmere School in 1917, and the building was formally dedicated on May 29, 1918. Students started classes in it the next day. Woodmere High School (at right) was built in 1926, and another wing was added to the grammar school in 1936. Designed by Henry Bacon, architect of the Lincoln Memorial, Woodmere High School was sold and then demolished to make room for garden apartments in the early 1980s. (HWPL.)

The faculty outnumbered graduates in the class of 1915. But by 1917, 40 students were enrolled in the secondary school, which had 15 teachers under the direction of Principal Charles S. Wright. The school board during those formative years was comprised of H. E. Jay, Smith Carman, Garry Brower, Emil Darmstadt, and Dallas Brower. (Hewlett-Woodmere Public Schools.)

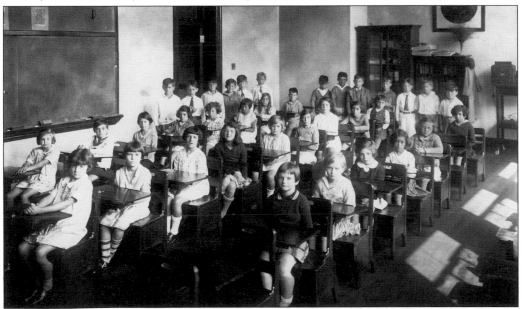

When this photograph was taken at Woodmere Elementary School in 1920, the primary and secondary grades no longer had to share the same school. The traditional eighth grade education had expanded, as more students attended secondary school than ever before. In addition to reading, writing, and arithmetic, the curriculum grew to include science, languages, the arts, and extracurricular activities. (Hewlett-Woodmere Public Schools.)

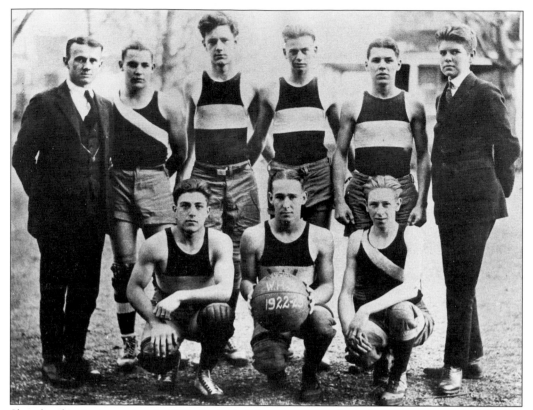

Shortly after its invention in 1891, basketball became a popular indoor sport at men's clubs like the YMCA and at colleges. Within a few years, it was offered as a competitive sport in local high schools as well. The 1922 basketball team from Woodmere High School poses with the coaches in the photograph above. (Hewlett-Woodmere Public Schools.)

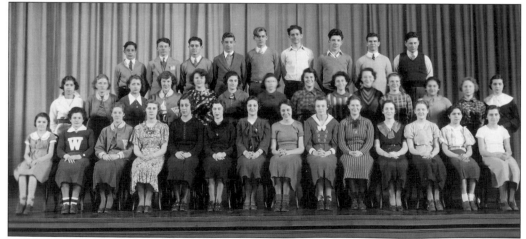

The glee club became a formal part of Woodmere High School's curriculum in February 1934 and, under the direction of Herbert G. Radtke, had a waiting list for membership by the 1934–1935 school year. As with the orchestra, glee club members received Regents credit for the course, establishing a tradition of musical excellence that has long been part of a Five Towns education. (Hewlett-Woodmere Public Schools.)

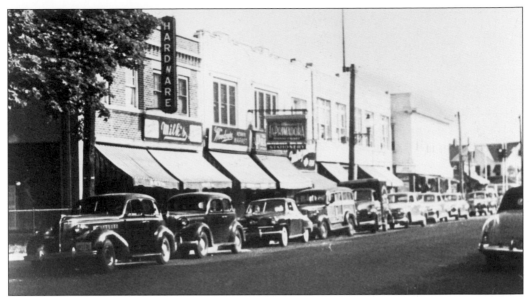

Milk's Department Store was one of the many fine shops that lined Broadway. Morris Milk, a Lithuanian immigrant, opened his store in 1898 on Broadway at Conklin Avenue. A fire in 1944 destroyed the store. Members of the four local fire departments were required to contain the fire. Milk's relocated down the street (above) and remained in business until the 1950s, when the Namm Loeser chain acquired it. (HWPL.)

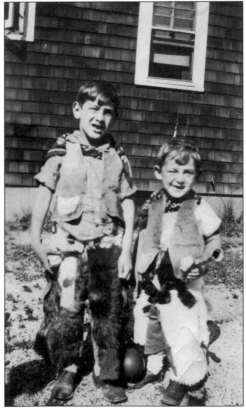

Morris Milk's grandsons, Robert (left) and Harvey (right), spent their early years in Woodmere. After serving in the Navy and teaching at Woodmere High School, Harvey Milk moved to San Francisco, where he was elected to the board of supervisors. Tragically assassinated in 1978, Milk was a charismatic and dedicated advocate for gay rights. He was posthumously awarded the Presidential Medal of Freedom in 2009. (Harvey Milk Foundation.)

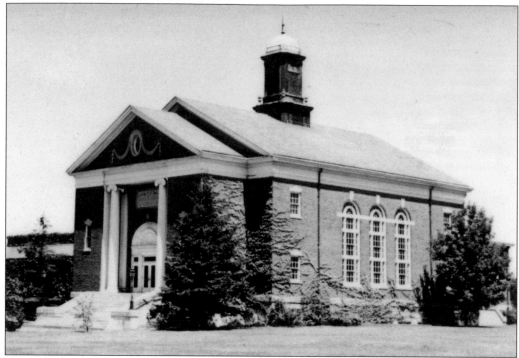

Woodmere Academy, a prestigious non-denominational institution, began in 1912 with 18 students. Two years later, the cornerstone was laid for the first of two buildings on its seven-acre campus. Dr. Horace Perry became the academy's first headmaster in 1934 and held the position for 25 years. In 1990, Woodmere Academy merged with the Lawrence Country Day School and now operates as the Lawrence-Woodmere Academy. (LC-PPD.)

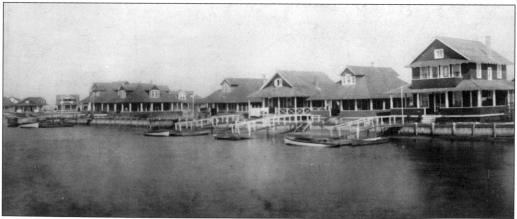

Meadowmere Park is an island neighborhood within the boundaries of the hamlet of Woodmere and the town of Hempstead. It is separated from the Queens neighborhood of Meadowmere by a canal. Because of this quirk in geography, it is the only area of Nassau that is located entirely west of Queens County. (NC-DPRM.)

William Fox (1879–1952), founder of the Fox Film Corporation, built his Woodmere estate, Fox Hall, in the 1920s. Fox, who made his fortune in a true rags-to-riches story, was one of the pioneers of the film industry. After the 1929 stock market crash, he lost his fortune, and, after a series of lawsuits and questionable business dealings, was never able to restore his wealth or his reputation. (Vanda Krefft.)

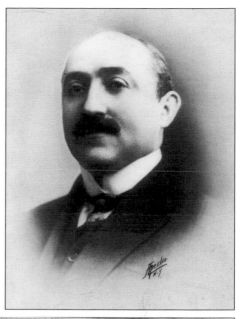

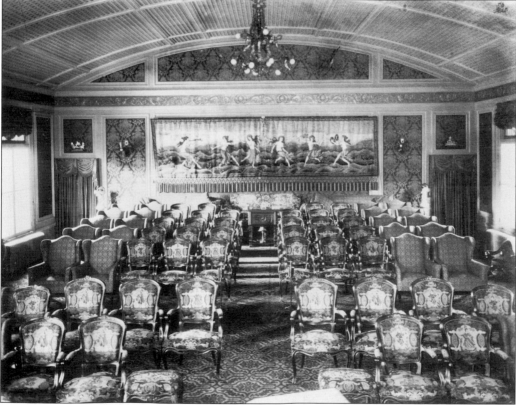

In this elegant movie theater at Fox Hall, 125 guests could view the latest films in luxurious privacy. The theater contained an orchestra pit and a Wurlitzer theater organ, which was installed in 1927. Residents remember that many major Hollywood personalities appeared in The Branch while they were visiting Fox Hall. (HWPL.)

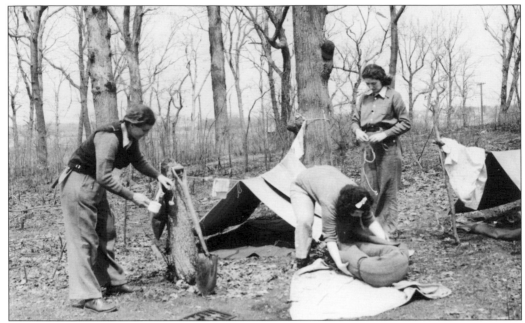

The Five Towns Council of Girls Scouts was established in 1929 and incorporated in 1934. Here, members of Troop 3 of Woodmere pose at a Girl Scout fair on the grounds of Woodmere Academy, on May 20, 1939. Under the leadership of Ethel DuBois, the girls from Woodmere High School were active in community service. Their scrapbook records several years of troop camping trips, crafts projects, and community service. (HWPL.)

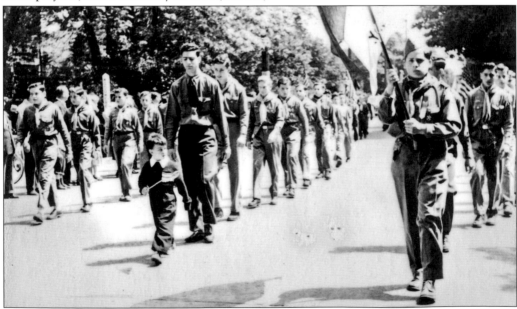

Local Boy Scouts march proudly in this 1949 parade. During the 1920s, Branch residents Edward C. Smith, Charles Hewlett, C. Willis Woodford, and William Piel were instrumental in establishing the Boy Scouts in Nassau County. Woodmere's Troop 21, under Scoutmaster Charles Hewlett, supplied the $100 binder required for the fledgling organization's purchase of Camp Wauwepex (in Wading River, New York) in 1926. (HWPL.)

Four

LAWRENCE

Prior to the Civil War, brothers Alfred, George, and Newbold Lawrence bought farmland in Rockaway Neck in the hope of creating a planned residential community to rival A. T. Stewart's Garden City. When the South Side Railroad explored the area in 1869, the Lawrence brothers offered the company land for a station, to be designated Lawrence. By 1886, the community contained over 100 mansions, many of them owned by members of the Rockaway Hunt Club, which located nearby. A plot of ground worth $100 in 1875 sold for $5,000 ten years later.

Development of Lawrence Beach, or "Back Lawrence," started in 1880 when Rufus W. Leavitt and other investors bought property from the Lawrence brothers. At the time, the ocean came directly to the beaches of Back Lawrence through an inlet between two growing sandbars that would eventually merge. In the Anglophile style of the day, the developers called the 45-acre area The Isle of Wight, after the British seaside resort. In 1884, developers erected the Osborne House Hotel (named for Queen Victoria's summer home) and its 18 cottages. The village of Lawrence was incorporated in 1897, the first of the Branch villages to do so. The incorporation greatly enlarged the boundaries of the municipality and transferred some parts of Cedarhurst into its jurisdiction. In 1938, the village acquired the land to build the Lawrence village golf course and in 1952 acquired the nearby Hicks Beach wetlands as a nature preserve.

At a time when many neighboring communities restricted sales to certain ethnic groups, an early community of Jews settled in Lawrence and established its first synagogues. The 19th-century Jewish community was centered in Manhattan and Far Rockaway. The first Jews in Nassau often had difficulty locating enough worshippers for daily prayer and had to travel to Manhattan for High Holy Days' services. The establishment of Temple Israel and congregations Shaaray Tefila and Beth Sholom signaled the beginning of a vibrant Jewish presence on Nassau's South Shore.

In 1869, when the South Side Railroad expanded its Rockaway Branch, the Lawrence brothers donated land for the train station at Lawrence Avenue and created or improved the connecting roadways. A station was built in 1872. It was replaced in 1905, and the original station house was moved to a private location in July 1906. (HWPL.)

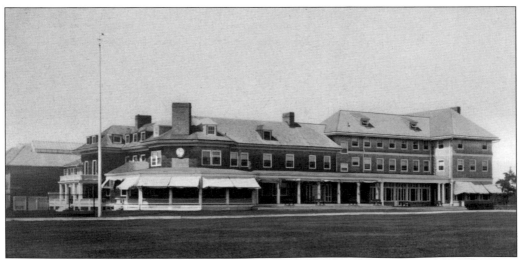

Founded in 1877 with 12 riders, the Rockaway Hunt Club (renamed the Rockaway Hunting Club in 1884) is listed as the nation's oldest country club. From its inception, members have been among the elite of New York society. The original clubhouse, which overlooked Reynolds Channel, was erected in 1888. When fire destroyed the building in 1893, it was replaced by this elegant Shingle Style building, designed by member James Monroe Hewlett. (HWPL.)

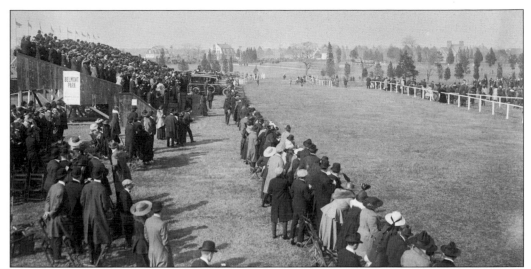

The four-mile steeplechase course was described in *Harpers Weekly* as "almost as level as a ballroom floor." Polo was introduced at Rockaway in 1881. Tennis was played as early as 1884; by 1905, the club had 16 courts. An 18-hole golf course was added in 1900, squash courts in 1901, and a toboggan slide in 1904. Baseball was played at the club as early as 1895. (LC-PPD.)

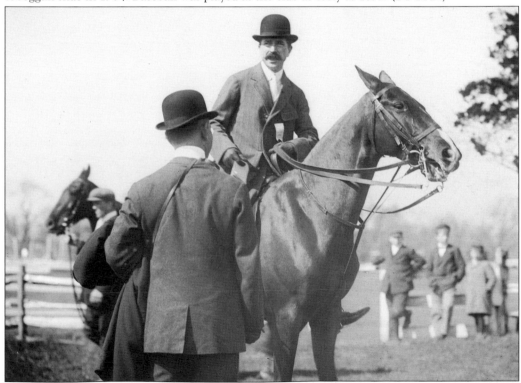

Foxhall P. Keene (1868–1941), the Gilded Age's most famous all-around sportsman, became a member of the Rockaway Hunting Club at 14. His exploits as a steeplechaser, jockey, polo player, golfer, amateur boxer, and race car driver and his "full-tilt" approach to living made him a celebrity on two continents. No one would bet against his father, industrialist and financier James R. Keene, when he offered to wager $100,000 on his son at $10,000 each in any 10 sports. (LC-PPD.)

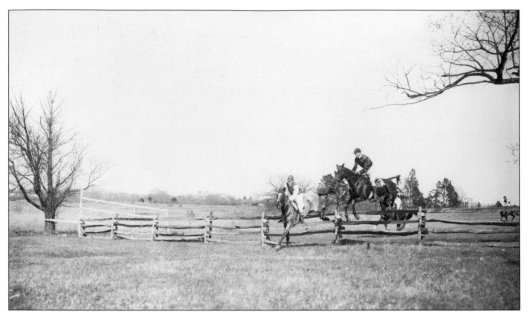

In its early days, Rockaway Hunt Club members rode across open country from Rockaway west to Jamaica or east towards Mineola, joining members of neighboring hunt clubs. By the 1890s, however, the area's increased population objected to riders jumping their fences and crossing their property. As fox hunting lost popularity on Long Island, the club flourished through increased interest in sports such as steeplechase (above), polo, golf, and tennis. (LC-PPD.)

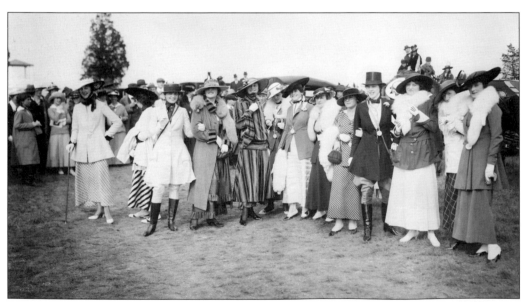

When this photograph was taken in 1916, women could attend Rockaway Hunt Club events as spectators, but they only had limited access to the clubhouse and were not served alcoholic beverages. Though some rooms were still off-limits as late as the 1960s, the regulations towards women were less restrictive by 1945. The club's first female governor joined the board in 1993. (LC-PPD.)

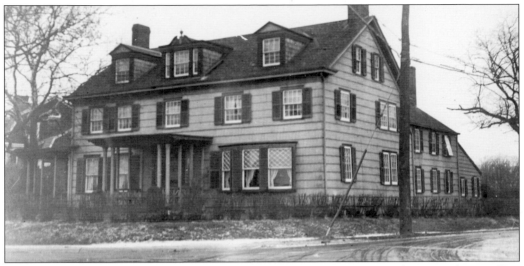

For over 50 years, the Jennings family owned the country store, stagecoach inn, and post office at the intersection of the Rockaway-Jamaica Turnpike and Rockaway Road (today's Broadway). Because they also owned most of the land surrounding the intersection, it was referred to as Jennings Corner. By 1923, when this photograph by Eugene Armbruster was taken, the building was a private home. (QL-LID.)

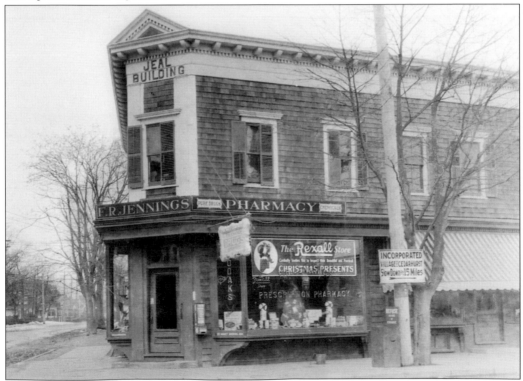

The Jennings Pharmacy, shown here c. 1910, was also located at the Jennings Corner intersection. Eliza Pettit Jennings (b. 1877) was one of the first female pharmacists to be licensed in New York state. She and her husband, Frank, moved their business to Hewlett in about 1920. After her husband's death, Eliza Jennings continued as pharmacist until she was 70 years old. (Linda Forand.)

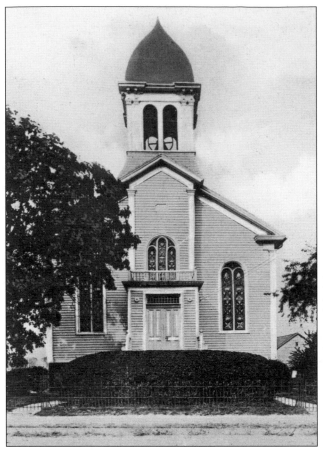

The building that once housed the Lawrence Methodist Episcopal Church was built on the site of McKendre's Chapel. The chapel, the oldest church in the Rockaway area, was built in 1831 when this congregation was established. After it burned to the ground in 1866, a new building was erected to replace it (left). The arrival of the railroad and the growth of the community necessitated the construction of an even larger building. In 1908, the new church on Rockaway Turnpike in Lawrence was completed (below). Designed by A. T. Ketchum, it incorporated the older structure into its design. The church's cemetery contains graves of the founders of the Five Towns dating back to 1833. The Lawrence Cemetery Restoration Project has been formed as a non-profit organization to preserve, restore, and protect this significant historic site. (Left, Our Lady of Good Counsel Church; below, HWPL.)

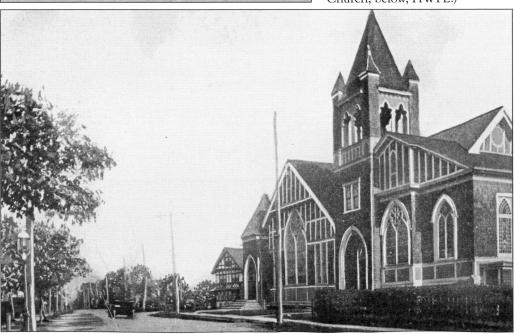

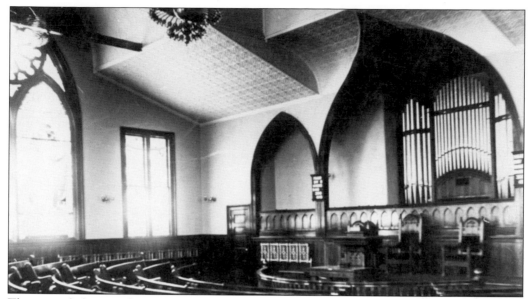

The stained glass windows of the former Lawrence Methodist Episcopal Church are considered among the finest on Long Island. Created by the Thomas Jones Window Decorating Glass Company of Brooklyn, four of the windows represent scenes from Hoffman's paintings of the life of Christ. The building now houses the Hispanic Christian Missionary Alliance. (QL-LID.)

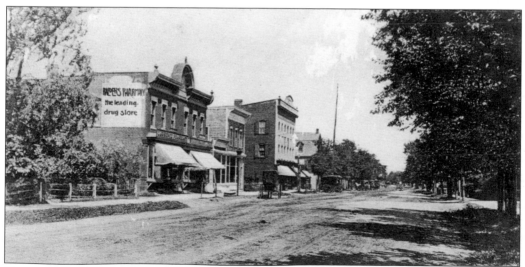

Horse carts line Central Avenue, the main thoroughfare of Lawrence, in this scene around 1912. In the summer, oil was spread on the road to limit dirt and dust on the unpaved streets. Shown above, Raeder's Pharmacy, like many of the larger establishments, marketed its own photographic postcards. (Our Lady of Good Counsel Church.)

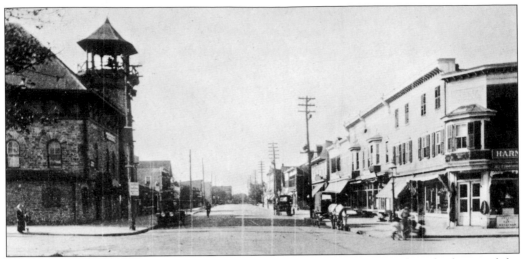

The most recognizable landmark in the area, Firemen's Hall (above left) is the home of the Lawrence-Cedarhurst Fire Department, a volunteer fire department since its charter as the Washington Hook and Ladder Company in 1883. This stone structure was built in 1902 with waste rock excavated during the construction of the New York City subway system. At one time, the building housed not only the fire department headquarters and fire station but also a meeting room and recreation hall. To help defray costs, additional space was leased to the Bank of Lawrence, and other parts of the building were leased for a courthouse, jail, and village clerk's offices. It has been decorated with patriotic bunting on many occasions, such as a 1906 YMCA athletic competition that attracted over 2,000 spectators and this 1917 farewell parade for World War I recruits (below). (Above, NC-DPRM; below, Linda Forand.)

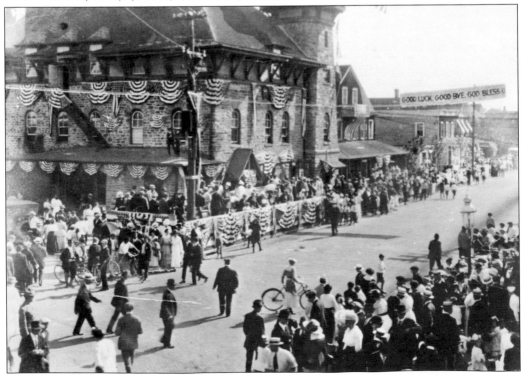

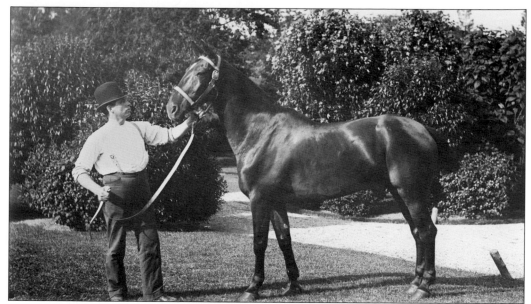

Fine horses, like the one shown here with its trainer, were a common site in The Branch. Early members of the Rockaway Hunt Club were avid horsemen. James R. Keene, a Wall Street stockbroker, was an internationally recognized breeder of thoroughbred horses. In 1908, *London Sportsman* magazine wrote that Keene possessed "the greatest lot of racehorses ever owned by one man." His Kentucky stable, Castleton Farm, produced six Belmont Stakes winners before he sold his holdings in 1910. (Photograph by J. H. Work; QL-LID.)

Between 1873 and 1884, the Lawrence brothers created neighborhoods of fashionable homes while retaining or recreating their natural settings. Briar Hall (above), one of four homes built as rental properties for Samuel Hinckley in the Rockaway Hunt section of Lawrence, was built in 1888 and designed by the firm of Lamb and Rich. Attorney James H. Work (1848–1916) and his family leased Briar Hall during the summer of 1892. (Photograph by J. H. Work; QL-LID.)

The clean, cool, and quiet of the beachfront properties contrasted with the polluted heat of the city. Here Marie Work (above) and her daughters (below) enjoy some of the attractions of summer at Briar Hall. Four of the six daughters—Sallie, Mabel, Jean, and Marie—play croquet. James H. Work eventually purchased The Gowans in Lawrence as a country home. He was later indicted for allegedly defrauding the Marine National Bank, causing the bank's failure and bankruptcy of the brokerage firm Grant and Ward, in which Pres. Ulysses S. Grant was a partner. Work's children retained their fondness for Lawrence as adults and kept their Rockaway Hunt Club connections. James Henry Work Jr. owned Engleside in Lawrence and served as a village trustee. (Photograph by J. H. Work; QL-LID.)

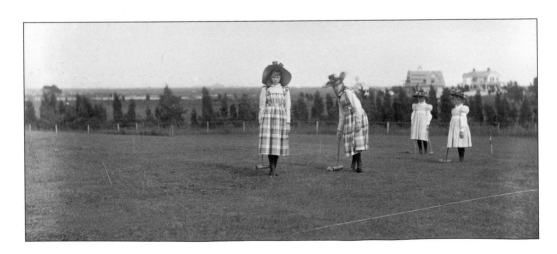

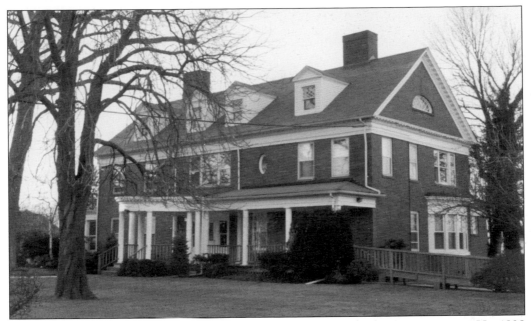

Dr. J. Carl Schmuck was a respected local physician and a civic leader for many years. His 1898 home, acquired by Lawrence village in 1945 and currently the village hall, was built on almost three acres of land with bricks imported from Italy. The beautiful paneling in the foyer was created from trees that grew on the property and were pickled in saltwater for three years before being milled. (Village of Lawrence.)

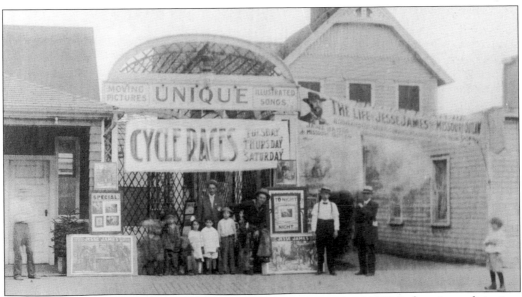

The Unique was an open-air theater that operated in Lawrence around 1900. Before air conditioning, vacationers and year-round residents depended on cool ocean breezes for their comfort. Open-air theaters, which featured events like bicycle races as well as moving picture shows, provided a popular diversion. The 1909 Sanborn map lists a "moving picture show," probably the Unique, on Central Avenue next to the firehouse. (Village of Lawrence.)

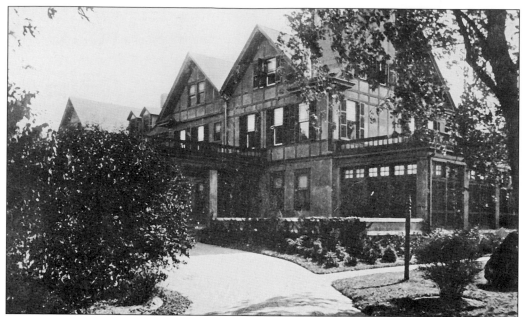

The White family, who lived in this home on Broadway in today's Lawrence, made their fortune from the waste of New York City. The New York Sanitary Utilization Company, founded by Patrick White, had factories on Barren Island in Jamaica Bay where bones and fat from animals were processed into fertilizer and grease. Patrick's sons, Thomas and Andrew, parlayed their Tammany Hall contacts into important government positions. (HWPL.)

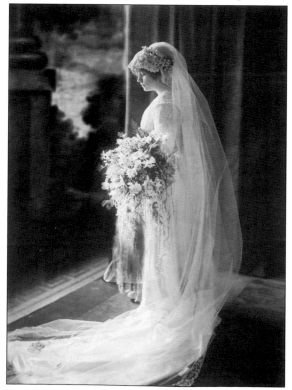

Both brothers became judges, and Thomas White (1864–1904) was appointed police commissioner of Brooklyn in 1877. When his daughter, Rosemary, married Andrew Feeney at St. Joachim's Church in 1912, a special train was chartered to bring 200 guests from New York and Brooklyn to join those invited from Cedarhurst, Lawrence, and Far Rockaway. (Feeney family.)

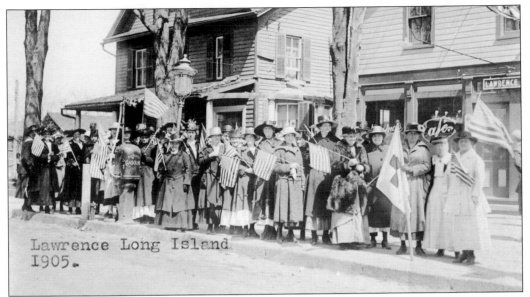

Lawrence Long Island
1905.

The dawn of a new century signaled an opportunity for women to exert their influence on society. With advances in education and communication, women became activists for causes like child labor, woman suffrage, or temperance. Whether supporting a cause, a charity, or the local fire department, ladies' auxiliaries and women's leagues became instruments through which women could change their world. (Our Lady of Good Counsel Church.)

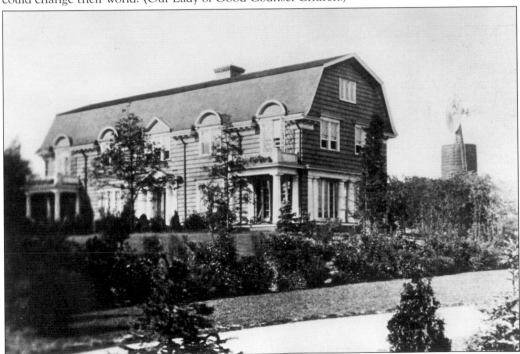

This 14-room home, nicknamed "The Ark," was built on Washington Avenue in Lawrence. Built in 1915 by Peter Strauss, it is one of a number of fairly large summer homes that were owned by families from New York or Brooklyn. The windmill was typical of those used to pump water from private wells. (Muriel Goldberger.)

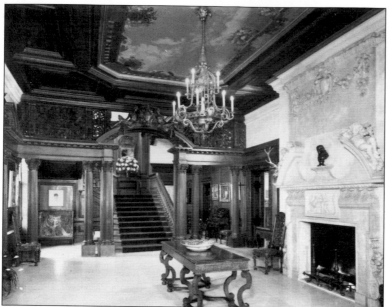

In the days before the stock market crash of 1929, money was no object in the construction of magnificent homes. The Castle, a 25-room red brick mansion located on The Causeway in Lawrence, was home to the Greenberg family. When Henry Greenberg, a builder, lost his fortune in the crash, the property was sold and many homes built on the grounds. (Joyce Goodman.)

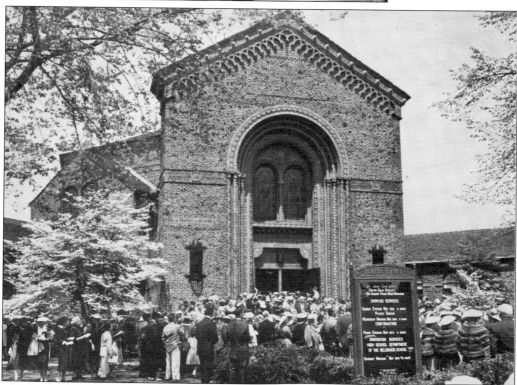

During the 1880s, German Jewish immigrants vacationing in the Rockaways met for informal religious services in a room above Nebenzahl's dry goods store in Far Rockaway. In 1908, Temple Israel was established in Far Rockaway, and by 1921, the Reform congregation had moved to Lawrence. Since the synagogue's dedication in 1931, Temple Israel has hosted such dignitaries as Herbert Lehman, Eleanor Roosevelt, Abba Eban, Elie Wiesel, Camelia Sadat, and Hillary Clinton. (Photograph by George Solomon; Village of Lawrence.)

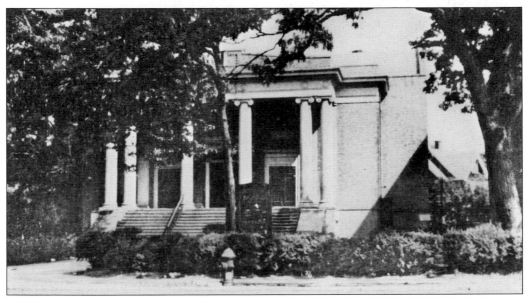

Congregation Shaaray Tefila of Lawrence is one of the oldest Orthodox congregations in Nassau. The synagogue in Far Rockaway (above) was founded in 1909 and relocated to Lawrence in 1925. The building later became home to the Hebrew Institute of Long Island, which in 1978 merged with the Hillel School in Lawrence to become the Hebrew Academy of the Five Towns and Rockaway, located in Lawrence. (Leiman Library.)

As the resort community became established, the Isle of Wight cottages rented for between $600 and $800 per season and included dining privileges at the hotel. The triangle-shaped community surrounding the Osborne House featured streets such as Victoria Place, Albert Place, Oxford Place, and Berkshire Place. Private homes were built on plots ranging from one to eight acres and sold for between $6,000 and $40,000 in 1882. (HWPL.)

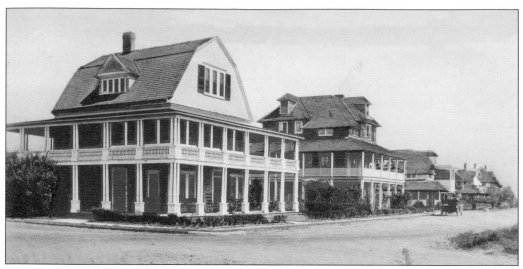

Summer cottages, like these on Sea View Avenue, were available for seasonal rental. The Osborne House Hotel's properties, which included the main building and 18 cottages, hosted such notables as Oscar Wilde and Henry Wadsworth Longfellow. Each of the hotel's guestrooms had a view of the sea. Guests residing in the cottages could take their meals in the hotel's dining room. By the time the Osborne House was destroyed by fire in 1900, the area had solidified its reputation as a summer resort. (HWPL.)

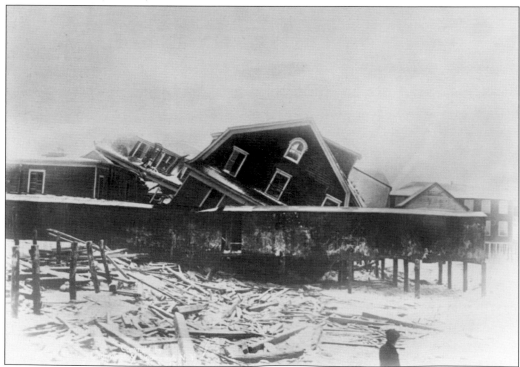

Major hurricanes hit the Long Island coastline about once a decade during the late 19th and early 20th centuries, causing major beach erosion, like this scene at Rockaway Beach. It was these hurricanes that changed the landscape at Lawrence Beach, which was open to ocean tides before the 1893 storm. (LC-PPD.)

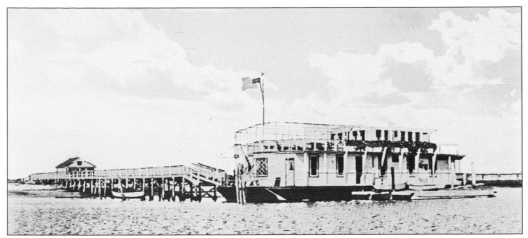

Incorporated in 1909 by members of the Rockaway Hunting Club, the Cedarhurst Yacht Club is located in Back Lawrence. Its houseboat served as the original clubhouse for members, their wives, and guests. The lower deck contained lockers and bathrooms, but the upper deck dining area featured a panoramic view and was used for many social functions. The structure was destroyed by arson in 1997, but was reconstructed by the club and is still in use. (HWPL.)

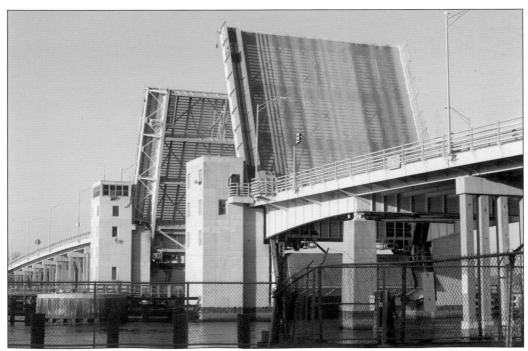

The Atlantic Beach Bridge replaced the ferry that once was the only means of reaching Atlantic Beach from Lawrence. When the bridge opened in 1927, the toll for automobiles was 25¢. It was privately owned until 1945, when it was purchased by Nassau County. Accommodating almost 20,000 vehicles per day, the drawbridge opens an average of 23 times daily to allow access to Reynolds Channel. (Photograph by Philip Vollono.)

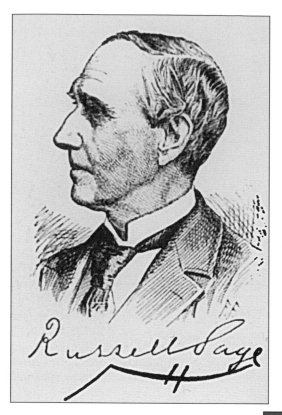

Through prudent management of his grocery business and property investments, Russell Sage (1816–1906) amassed a fortune, engaged in banking, and pursued a political career. After serving two terms in Congress, he became involved in managing no less than 27 railroad companies and was a director of several New York financial institutions. He had an encyclopedic knowledge of horses and reportedly loved racing Meek and Humble, his pair of matched colts, down Central Avenue. (Freeport Memorial Library.)

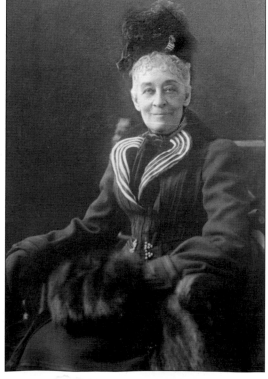

Margaret Olivia Slocum Sage (1828–1918) lived for almost 40 years in the shadow of her husband, a frugal and ruthless businessman. At his death in 1906, she inherited an estate of over $50 million, which she allocated for educational and social improvements. The Russell Sage Foundation, which she established with an initial grant of $10 million in 1907, has become one of the world's preeminent institutions for social science research. (LC-PPD.)

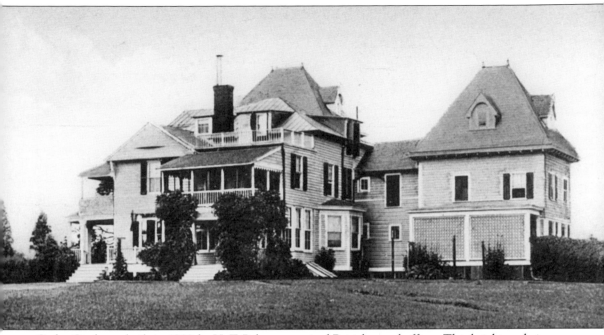

Cedar Croft was built in 1888 for H. T. Palmer, a retired British naval officer. This bright and airy Shingle Style home was acquired by Russell and Olivia Sage around 1886 and became a treasured summer residence. During his last illness, Sage enjoyed watching the ships pass as he sat sheltered in the airy verandas that shielded him from the sun and wind. (QL-LID.)

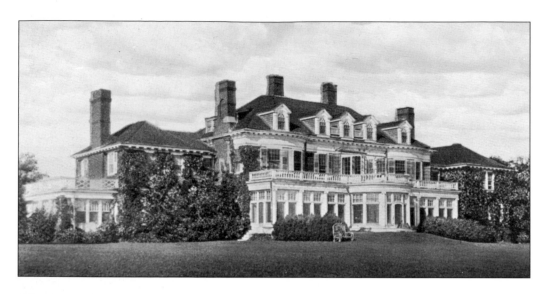

Albro House (above) was built for Robert L. Burton in 1898. John Howes Burton (d. 1946) acquired the property after his brother's death in 1927. The firm of Burton Brothers was among the largest cotton manufacturing firms of its time. While Robert Burton (below in the straw hat) invested his money in the development of Woodmere, J. H. Burton used his influence to change the face of New York City. His Save New York committee advocated the preservation of Fifth Avenue as a shopping district and the relocation of Manhattan's Garment District to Seventh Avenue. In the 1930s, Burton was a promoter of the construction of roadways to join Manhattan with the Long Island beaches. His plans for an East River tunnel at 38th Street (today's Queens-Midtown Tunnel) were postponed when World War II began. (Above, HWPL; below, NC-DPRM.)

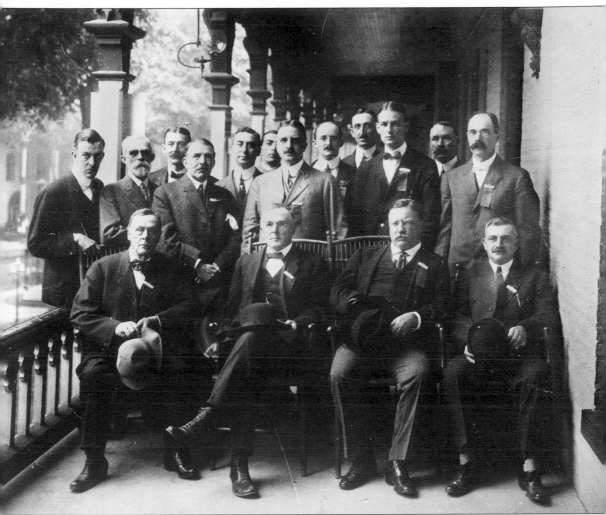

Franklin B. Lord (1850–1908) (second row, far left) is pictured with representatives to the New York State Republican Convention at Saratoga in September 1900. Lord, the first president or mayor of Lawrence, was from a family of prominent lawyers. His father, Daniel Lord, was a Harvard-educated attorney and considered one of the most respected counselors in New York City. The family's extensive land holdings, commonly known as Lords' Woods, reached from the Long Island Rail Road tracks to the Queens border and included a dairy farm in Lawrence and, eventually, the holdings of the Queens County Water Company. New York Gov. Theodore Roosevelt (first row, second from right) had recently been selected as a vice presidential candidate. Within the year, the assassination of William McKinley would make Roosevelt the youngest president of the United States. (NC-DPRM.)

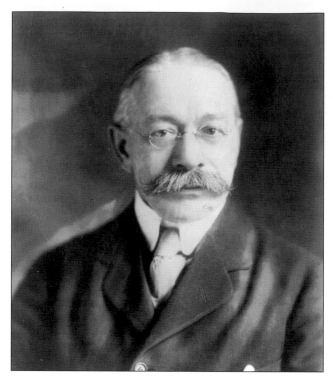

A distinguished corporate attorney, George Woodward Wickersham (1858–1936) was appointed attorney general under Pres. William Howard Taft. With Taft's 1912 defeat, Wickersham returned to private practice in New York. He is remembered for his breakup of corporate monopolies and his chairmanship of the Wickersham Commission, which examined causes of criminal activity in America. As one of the court-appointed guardians of the child heiress Gloria Vanderbilt, Wickersham was praised for his prudent management of her fortune. (LC-PPD.)

Mildred Wendell Wickersham (d. 1944), an avid gardener, collaborated with landscape architect Mary Rutherfurd Jay on the Japanese garden at Marshfield, her Lawrence estate. They created artificial islands in the pond and planted evergreens, rhododendrons, bamboo, and azaleas. Architects at Foster, Gade and Graham designed Marshfield. The Wickershams, noted for their gracious entertaining, were among several families who annually opened their gardens to guests on behalf of local charities. (LC-PPD.)

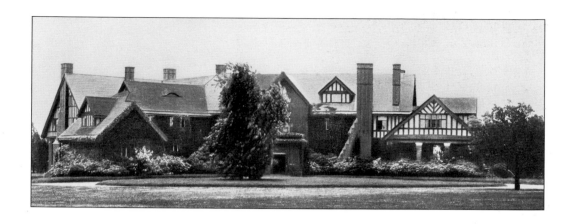

Talbot House (above) on Longworth Crossing in Lawrence was the home of Talbot J. Taylor (at left below) and his family. His wife, Jessica, was the daughter of stockbroker James R. Keene. Taylor joined Keene's Wall Street firm and lived the life of a country squire. The extensive collection of antiques housed at Talbot House was the subject of his 1906 book. When Jessica Taylor suspected that Talbot's relationship with his interior decorator was more than professional, she divorced him, forcing him to auction the entire collection. James H. Work photographed Taylor (at the wheel) with his chauffeur in front of Talbot House. (Above, HWPL; below, QL-LID.)

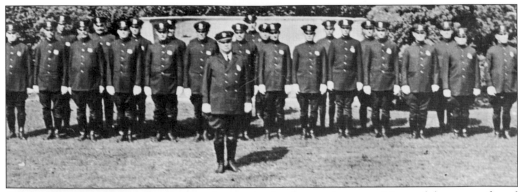

Coachmen and gardeners provided early security for the great estates. Many of these men found employment as community police officers. Most community police forces disbanded when the Nassau County Police Department was created in 1925. Lawrence retained its own police force and bought its first police car and several motorcycles in 1926. The department was dissolved in 1941, and the Nassau County Police Department took over its duties. (Village of Lawrence.)

After a career in New York City's police department, Abram Skidmore of Cedarhurst was requested by village officials to head the Lawrence Police Department. During his two years as captain of the Lawrence police, Skidmore attracted the attention of Town Supervisor Doughty, who persuaded Skidmore to head the newly created Nassau County Police Department. In April 1925, Skidmore was officially named chief of the 55-man department. (Nassau County Police Department Museum.)

In 1928, when voters rejected a referendum to fund a public library, an alternative emerged, creating a fee-based children's library. The Peninsula Community Library opened as a storefront in Cedarhurst in 1931 and soon moved to a larger structure. A memorial fund enabled the purchase of a core collection. Funding from the Five Towns Community Chest, private subscriptions, and donations provided everything else. Miriam Rowe served as librarian from 1930 to 1950. (HWPL.)

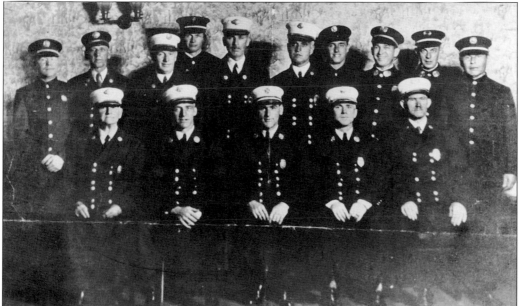

Members of the Lawrence-Cedarhurst Fire Department pose for a portrait in this 1935 photograph. Nicknamed the "Screech Owls," the fire department has a history of community service dating back to its formation in 1883. The Five Towns' fire companies form a cooperative network of service and camaraderie, laced with a bit of friendly competition, which spans generations of local residents. (Rita Bowker.)

Cornelius Wickersham (1884–1968), son of George and Mildred Wickersham, balanced his career between the military and his corporate law firm. After World War I, he maintained his reserve status and later commanded the Army School of Military Government. After World War II, Wickersham was one of the officers in charge of U.S. occupation forces in Germany. Active in the National Guard and the Army Reserve, "The General," as he was known, applied his efforts to community projects as well, helping to form the Peninsula Community Library and the American Legion. (LC-PPD.)

William Dowdell Denson (1913–1998) served the village of Lawrence from 1966 to 1976, first as a trustee, then as mayor. A native of Alabama, Denson was the subject of Joshua Greene's 2003 book *Justice at Dachau*. Denson was the chief prosecutor of the Dachau war crimes trials from 1945 to 1948, in which 177 Nazi war criminals were successfully prosecuted. Although 97 were hanged for their crimes, some sentences were compromised by the politics of the Cold War. (Photograph by Fabian Bachrach; Village of Lawrence.)

Five

CEDARHURST

Brothers Thomas E. Marsh and Samuel A. W. Marsh were grain merchants from New York City who decided to invest in real estate development in the Rockaways. In 1869, they donated land to the South Side Railroad for a station to be named Ocean Point. They subsequently acquired farms and land from West Broadway to Broadway in one direction and from the Woodsburgh boundary at Prospect Avenue to the Lawrence boundary at Washington Avenue in the other direction. The main thoroughfare, Central Avenue, was constructed in conjunction with adjacent landholder Alfred Lawrence, extending the avenue through the neighboring village of Lawrence.

In 1872, the Long Island Rail Road built a shorter route from Jamaica to Ocean Point, its tracks continuing from Ocean Point to Far Rockaway, paralleling the South Side's. That year, the Marsh brothers, anticipating a real estate boom, auctioned the rest of their property in small parcels. With the organization of the Rockaway Hunt Club in 1884, a post office was established on the club premises and given the more descriptive name Cedarhurst, for the adjacent grove of cedar trees. When Lawrence was incorporated, many of the borders changed. Earlier Cedarhurst properties, many of the principal estates, and public buildings, including the Rockaway Hunt Club, acquired a Lawrence address.

Civic leaders saw in the increased population and land development a need to anticipate and fund public works projects. Village leaders applied for a charter, and Cedarhurst was incorporated on September 10, 1910. At this time, a coordinated plan for civic development, financed by municipal bonds, resulted in the construction of a state-of-the art residential and business community with paved roads, telephone systems, a fire department, and gas and electric connections at a time when most municipalities did not have these amenities.

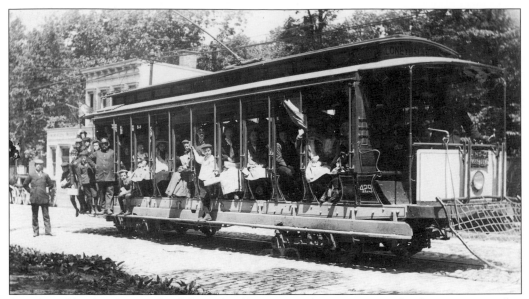

Streetcars like this Coney Island–bound trolley improved transportation for the average traveler. The journey might begin with a ride from Jamaica to Rockaway Turnpike in Cedarhurst. The 10-mile route then continued down Lawrence Avenue, through Inwood, to Far Rockaway, where the line ended. The Long Island Electric Railway Company charged 10¢—a third of the price of a ticket on the Long Island Rail Road's Rockaway Branch. Electrified in 1905, the LIRR eventually replaced the trolley service. (IIWPL.)

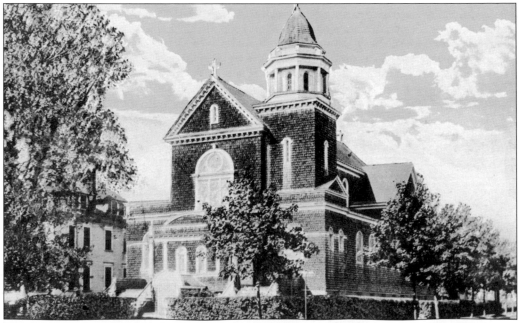

The Church of St. Joachim began in 1899, when St. Joseph's in Hewlett purchased property on Central Avenue in Cedarhurst to build a mission church. During a violent thunderstorm in 1907, the structure was hit by lightning and burned to the ground. It had to be rebuilt once more after it caught fire during the reconstruction. Today St. Joachim's remains almost unchanged in appearance from this 1914 postcard. (HWPL.)

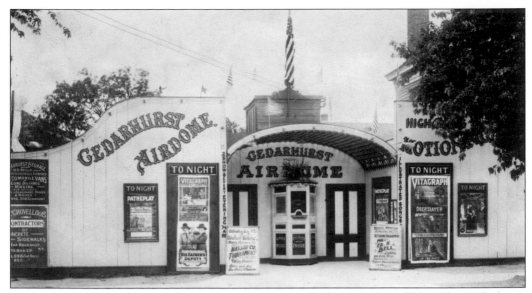

Open-air theaters provided cool summer entertainment in the early days of film. The Cedarhurst Airdome, which opened in May 1899 on Spruce Street near Cedarhurst Avenue, was an outdoor auditorium that featured vaudeville as well as moving pictures. The Cedarhurst Playhouse may have been built on this site in the 1920s. (HWPL.)

The stately 1902 Cedarhurst School (right) replaced the two-room schoolhouse on Frost Lane. It served until 1922 when Number Three School was built. The first Lawrence High School graduated 15 students in 1915. The current Lawrence Middle School building, erected in 1936, served as Lawrence High School until the present structure was built in 1960. (Our Lady of Good Counsel Church.)

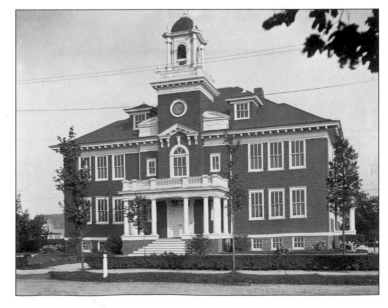

When this family took a Sunday drive in 1906, Cedarhurst consisted of a hotel, three saloons, a blacksmith shop, two butcher shops, a barbershop, two grocery stores, a funeral parlor, an insurance office, and not much else. The paving and curbing of Central Avenue was the first large civic project undertaken after Cedarhurst's incorporation. (HWPL; Photograph attributed to Wallace Smalls.)

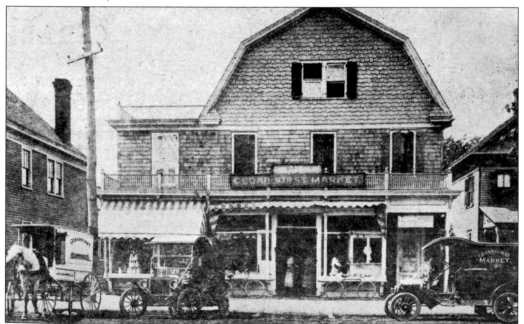

This hub of commercial activity was the Cedarhurst Meat Market on Central Avenue, around 1905. The market was owned by Charles M. Searles, later a trustee of the village of Cedarhurst. In front of the Sheffield Farms Market (at the left of the photograph), both horse and driver eagerly await their delivery assignment. (*Nassau Herald*; HWPL Collection.)

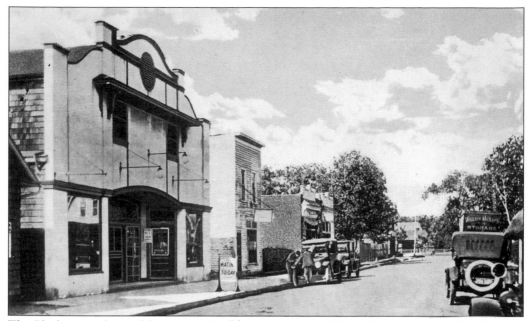

The Playhouse, a beautiful Art Deco building, opened in 1924 on Spruce Street. For 20 years, it was on the "straw hat circuit." Summer seasons of vaudeville and stage plays supplemented its nine-month season of cinema performances until, in 1946, the Playhouse became a full-time movie theater. Limited by small seating capacity, lack of air conditioning, and competition from the larger Central Theatre, the Playhouse closed in the late 1940s and was later demolished. (HWPL.)

The desire for more local control of civic functions created the village of Cedarhurst, which was incorporated in 1910. The first mayor, Horatio P. Vandewater, died after only one year in office and was replaced by David Weyant. Village trustees and officers shown here are, from left to right, (first row) Arthur M. Lockhart, David H. Weyant, and John McNicoll; (second row) William D. Reilly, George W. Craft, Albert T. Moon, Lewis M. Raisig, and Fred L. Gilbert. (NC-DPRM.)

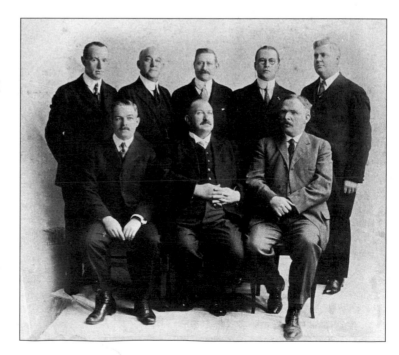

Since the creation of Central Avenue as Cedarhurst's main thoroughfare, the most fashionable stores in The Branch have located in the Cedarhurst business district. Central Avenue (shown here c. 1915) always featured exclusive boutiques and catered to expensive tastes. By 1941, there were 200 shops in the one-square-mile business district. Chic chain stores have gradually replaced many of the unique, privately owned establishments. (HWPL.)

Suffolk farms supplied fresh vegetables for Ernest Elderd's store. In 1918, as Central Avenue was transformed from a dirt road to a major thoroughfare, Elderd put his home on rollers and moved it to Willow Avenue. The gap left on Central Avenue became the home of Elderd's Market. After 10 years as a village trustee, Elderd served as mayor of Cedarhurst from 1936 to 1959. (HWPL.)

It is estimated that 20,000 Ku Klux Klan members lived on Long Island in the early 1920s, some of them in the Branch communities. A *New York Times* article from November 30, 1923, describes a near riot at the dedication of a war memorial in Cedarhurst Park, when a group of Klansmen tried to add its wreath to others on the granite monument. By 1926, the movement had lost its momentum in the area. (LC-PPD.)

The woods and fields in this 1924 aerial view of Cedarhurst are only memories, but the distinctive pathways of Cedarhurst Park are easily recognizable. A main feature of today's park is the beautiful Victorian-style gazebo where summer concerts attract appreciative crowds. The Memorial Teaching Plaza offers an eloquent tribute to those who served the village, those in the military, and the lives lost on September 11, 2001. (NC-DPRM.)

Between 1937 and 1941, the Cedarhurst Municipal Stadium, located on the site of today's Lawrence High School, hosted minor league and semi-professional baseball and football teams with names like the Cedarhurst Giants, Wolverines, All-Stars, Gaels, and Spartans. From 1938 to 1941, Cedarhurst Stadium also maintained a quarter-mile racing track for midget racing. Drivers like Bill Schindler, "Honey" Purick, Ed "Dutch" Schaefer, and Tony Bonadies competed in furious 75-lap heats. The first American Racing Drivers Club (ARDC) race was held on May 15, 1940, at Cedarhurst. Unfortunately, the deaths of drivers Brad Stillwagon and Andrew "Honey" Purick at the track in June and July 1940 contributed to the end of midget racing at Cedarhurst. Events ceased during World War II, and the stadium never recaptured its popularity after the war. (Both Himes Museum of Motor Racing Nostalgia.)

Six

INWOOD

First settled around 1817, Inwood's earliest residents depended on Jamaica Bay for their livelihood. Originally called North West Point, the community was named for its location on the peninsula. These descendents of Hempstead's first settlers had a reputation for rowdiness. The coming of the railroad opened the area to commerce and ended much of the isolation that the community enjoyed.

When the Lawrence brothers built roads to facilitate travel to their properties, North West Point's Bayview Avenue was connected to neighboring communities via Lord Avenue. By the 1880s, North West Point, now called Westville, was a prosperous settlement. The Westville docks functioned as a depot for the distribution of shellfish shipped all over the world. According to *The Story of the Five Towns*, Westville in 1885 "boasted a library, a law office, a private school, a literary society, two pharmacies, a resident clergyman, a physician, a tonsorial artist . . . a fire company and a brass band." In 1888, when Westville residents applied for a post office, they found that the name had already been taken. Residents agreed on the name Inwood as an alternate choice.

Inwood's earliest Italian residents immigrated to the United States from Calabria and Sicily around 1890. Usually stopping in larger urban centers before settling on Long Island, they were willing to make sacrifices in the hope of a better life. These newcomers found work in the fishing industry, the building trades, and agriculture. By 1900, Inwood had the largest Italian population in Nassau County. Concentrated in the Crow Hill section, the Italian community occupied Mott Avenue, St. George Street, and Clinton Street in the early 1900s. Soon able to buy their own homes, they constituted a substantial minority in the town.

The Five Towns Community House, derived from Margaret Sage's Industrial School, was one of several agencies that helped immigrants adapt to their new home. Providing vocational training as well as recreational and civic functions, the Community House and the Church of Our Lady of Good Counsel were centers for an energetic and active population.

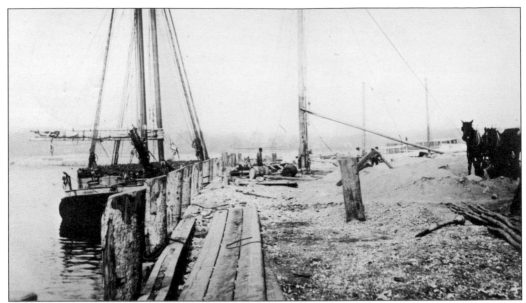

Until 1887, a steam launch carried passengers and freight from the Westville dock over Jamaica Bay to New York City. Pollution in the bay became a problem in the mid-1800s. Though legislators like G. Wilbur Doughty tried to enact laws to protect the oyster beds, New York state eventually halted commercial oystering in Jamaica Bay, effectively destroying a local industry. (Our Lady of Good Counsel Church.)

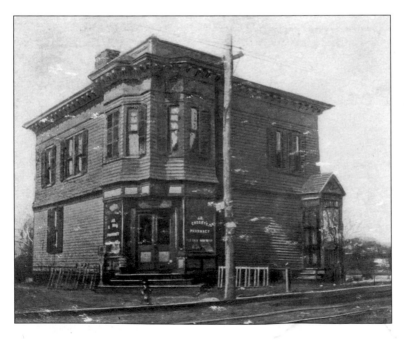

John D. Crosby, owner of the Excelsior Pharmacy, was appointed as Westville's first postmaster on February 25, 1889. He held the position until the end of the first World War. Crosby was also fire chief during the early years of the Inwood Fire Department. (Our Lady of Good Counsel Church.)

St. Paul's Methodist Episcopal Church was founded in 1879 at the home of Henry Wanser of Inwood. The 22 charter members shared their homes for services until December of that year, when the first church was erected at the corner of Lord and Redwood Avenues. The old building was moved and then used as the nucleus for a new structure (right). Though the church was destroyed by fire in 1969, the congregation relocated in the neighborhood. (Our Lady of Good Counsel Church.)

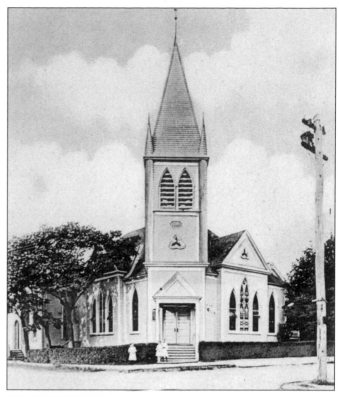

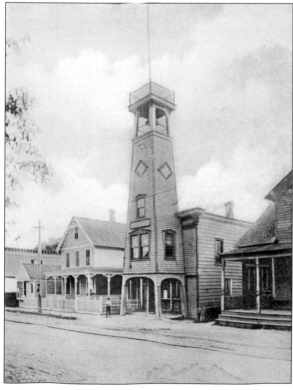

The Inwood Fire House was erected in 1887 at what is now 101 Doughty Boulevard. Before the telephone, someone wanting to report a fire would have to run to the firehouse and ring the bell in the tower to summon firefighters from all over town. Because of the lack of pumping equipment and hydrants, most of the activity was focused on saving lives rather than property. (Our Lady of Good Counsel Church.)

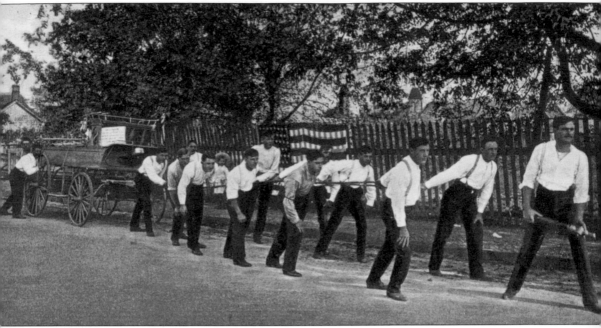

In 1887, a meeting of concerned citizens at Edward Rhinehart's home resulted in the formation of the Electric Hook and Ladder Company of Inwood. A second fire company, Citizen Hose and Engine, was formed in 1902 by some of the younger members of Electric Hook and Ladder, but the two companies soon merged and were incorporated as the Inwood Fire Department in 1910. Inwood's "Mud Ducks" won first place in the Southern New York Tournament of 1905. (Our Lady of Good Counsel Church.)

Inwood's firehouse is on the northeast corner of Wanser Avenue and Doughty Boulevard. The building, dedicated in 1928, houses not only the trucks and other apparatus but contains meeting rooms and a recreation hall, making the firehouse a home away from home for its dedicated members. An extension was added in 1952, and an annex was built in 1984. (Our Lady of Good Counsel Church.)

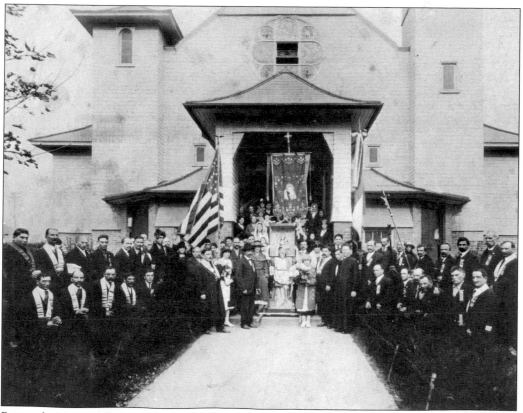

Primarily from Calabria and Sicily, the early Italian residents of Inwood immigrated to the United States around 1890. Many of the Calabrian immigrants were descendents of Albanians who fled the Turkish Empire in the 1500s. The hub of an active, involved community, the Church of Our Lady of Good Counsel organized activities such as the San Cono festival parade, a tradition that still continues. (Aldo and Angela Perrino.)

Inwood's Stella Albanese Society was founded in 1897 as a fraternal organization dedicated to preserving the unique cultural traditions of the Italo-Albanian community. Inwood's social, fraternal, and benevolent organizations included the Odd Fellows, Lions Club, Police Boys Club of Inwood, and the Inwood Homeowners Civic Association. (Aldo and Angela Perrino.)

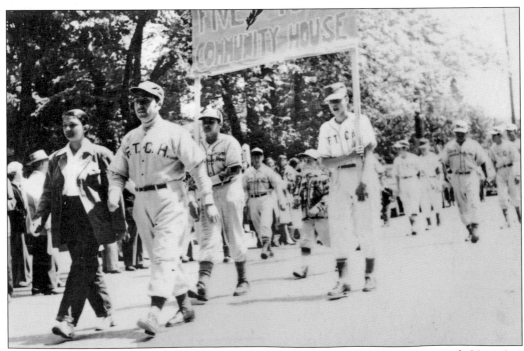

The Sage Industrial School, founded in 1907 as a vocational school for immigrant children, has consistently provided recreational, cultural, and health programs for the community. The institution, later named the Settlement House of the Five Towns Community Chest and the Five Towns Community House, also provided services for families in need. The 1931 establishment of the Five Towns Community Chest was the first time that the term "Five Towns" was used. (HWPL.)

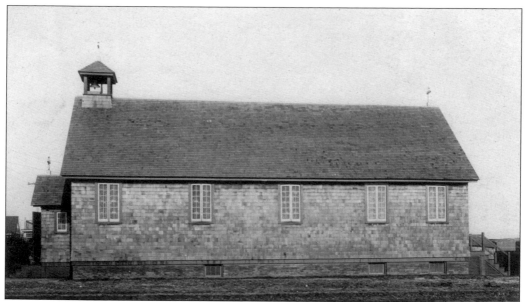

The increased population of Italian immigrants in Inwood created a need for a Roman Catholic house of worship. In 1905, the Far Rockaway congregation of St. Mary Star-of-the-Sea acquired property in Inwood for the establishment of a school and settlement house. The first mass was held in the chapel of Our Lady of Good Counsel on Christmas morning 1909, and the new church was dedicated in the spring of 1910. Rev. Luigi Salamoni was entrusted with the care of the mission until 1910 when Rev. John J. Mahon (right) was appointed rector of the new parish. (Our Lady of Good Counsel Church.)

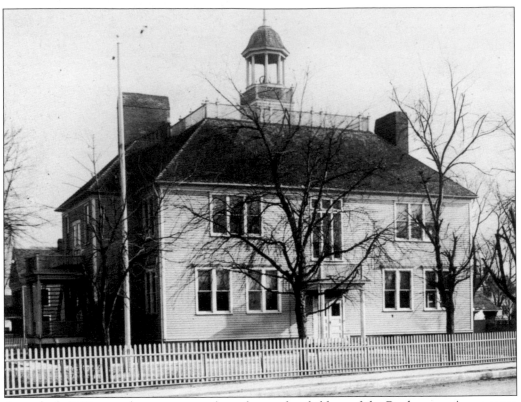

As early as 1830, a teacher was engaged to educate the children of the Rockaways. A one-room schoolhouse near the present corner of Broadway and Carman Avenue in Cedarhurst attracted students between the ages of four and 21, who came by foot or by cart with their lunch pails in hand. A two-room schoolhouse on Broadway and Frost Lane opened in October 1869. Principal George Wallace was the sole employee. When New York state established the Lawrence School District in 1891, a dozen teachers taught less than 300 students. Fred DeLancey King became the new district's principal and first superintendent. One annex served the children of Lawrence, and the Inwood School (above) served as an annex for children who lived in Inwood. The Number 2 School (below), still in use, replaced the Inwood School when it was demolished in 1920. (Our Lady of Good Counsel Church.)

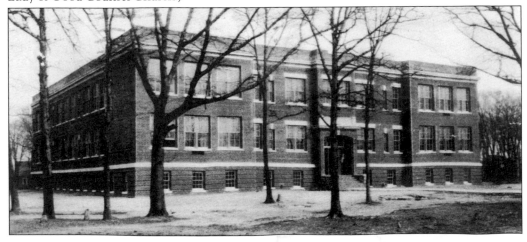

When New York's counties were established in 1683, the town of Hempstead was within the boundaries of Queens. Though town residents showed interest in separating as early as 1859, it was not until 1898, when the western part of Queens became part of New York City, that a serious secessionist movement began in Hempstead. In 1899, Nassau County was established. Assemblyman G. Wilbur Doughty of Inwood (right) was instrumental in returning portions of the Branch communities to Hempstead. Doughty went on to become the county Republican leader and the supervisor of the town of Hempstead. His nephew, J. Russell Sprague (below), also of Inwood, became the first county executive of Nassau County. Doughty and Sprague were instrumental in the formation of the powerful Nassau County Republican machine, which controlled county government for the rest of the 20th century. (NC-DPRM.)

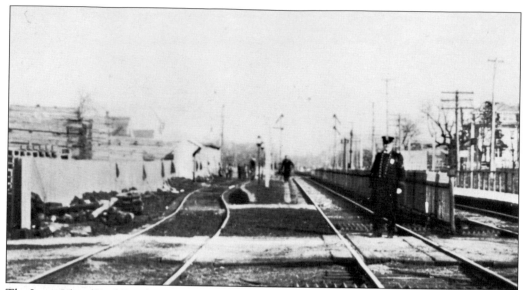

The Long Island Rail Road station at Inwood is the last Nassau County stop on the Far Rockaway line. In this 1911 photograph, a team of workmen constructs the first Inwood station under the watchful eye of railroad security. Located at Bayview Avenue, the original shed was demolished in 1956. (Author's collection.)

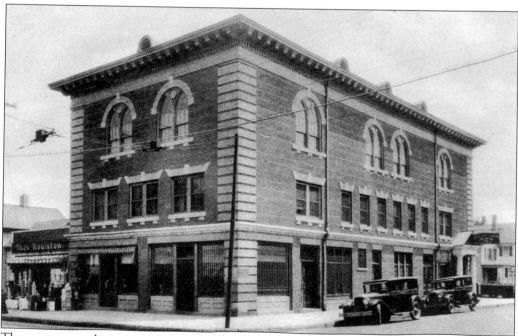

The new century's prosperity generated the establishment of local banks like the First National Bank of Inwood, founded in 1923. The building, at the corner of Doughty Boulevard and Elizabeth Street, now contains stores. The bank itself merged into other financial institutions during the 1960s. (Our Lady of Good Counsel Church.)

World-class golf courses like the Rockaway Hunting Club (*c.* 1891) and the Inwood Country Club (1901) were soon joined by the Woodmere Club (1910), Seawane Club (1927), Lawrence Village Country Club (1930) and others. The Inwood Country Club gained international recognition as the site of the 1923 U.S. Open. As the field narrowed, 21-year-old Bobby Jones (above) defeated veteran golfer Bobby Cruickshank in a tense, 18-hole playoff to win the tournament. (LC-PPD.)

First named Mott Street, Bayview Avenue was one of the four original streets in Inwood. This 1930 view faces west from the corner of Marvin Street. Typical of Inwood's working-class neighborhoods, the avenue's residents provided many of the service occupations that supported wealthier communities. In the 1930s, Inwood's harbor became a storage depot for petroleum products. A pipeline under Jamaica Bay connects Inwood with refineries in New Jersey. (NC-DPRM.)

Four generations of a family are pictured at their Inwood home. From left to right are Una Cahill Perine (b. 1917), her mother Bertha Bedell Cahill (b. 1899), grandmother Maude Little Bedell (b. 1882), and great-grandmother Hannah Allen Little (b. 1860). Hannah's father David Allen (b. 1835) was a local carpenter. These women, like many of their Inwood neighbors, supplemented their family's income by taking in laundry. (Alex Cummings.)

An attorney and the first president of the Nassau County Bar Association, William Soper Pettit was active in the unsuccessful movement for Rockaway's secession from New York City. Pettit was very involved in community affairs and was on the first board of trustees of the Hewlett-Woodmere Public Library. After his death in 1948, Pettit's Lawrence home became the headquarters of the Five Towns YMCA, an institution he helped to found. (Linda Forand.)

Seven

AFTER THE WAR

Major demographic changes resulted from suburban population growth after World War II. As families moved from New York City to Nassau and Suffolk Counties, the Five Towns continued to attract business and professionally oriented workers, many of whom commuted daily to Manhattan. Five Towns women of the 1950s concentrated on raising families and participating in community and religious organizations; country clubs, PTA, music clubs, and garden clubs abounded. Subsequent decades saw the construction of more public schools to accommodate the community's growing needs. In addition to the existing private schools, the number of private religious schools increased substantially, attracting students from all over the metropolitan area.

As a result of the postwar increase of the area's Jewish population, the Five Towns is today considered one of the cultural centers of American Judaism. The thriving communities encompass many different philosophies and have greatly influenced the character of the villages.

Upwardly mobile and well-educated newcomers skewed the financial statistics so that Five Towns villages began to consistently appear on lists of wealthiest Long Island communities. Depending on the eye of the beholder, prosperity manifested itself as the fulfillment of the American dream or a spectacle of conspicuous consumption. During the prosperous decades after World War II, the boutiques of Cedarhurst supplied any commodity from haute couture to fur-coated Cabbage Patch dolls for those who could afford it. The term "Five Towns" for a time became synonymous with glamour, glitz, and excess.

There has been an African-American presence in The Branch since colonial times. Before World War II, Long Island's African-Americans made up about two percent of the general population. In the 1920 census, black residents numbered about 100 individuals. Very few of those listed in the census were born in New York. Most came from Southern states or the Caribbean. Listed as laborers, butlers, chauffeurs, maids, and laundresses, the professions are similar to those of white immigrants. The Five Towns African-American population, mostly in Inwood and Lawrence, would not reach significant numbers until the 1960s.

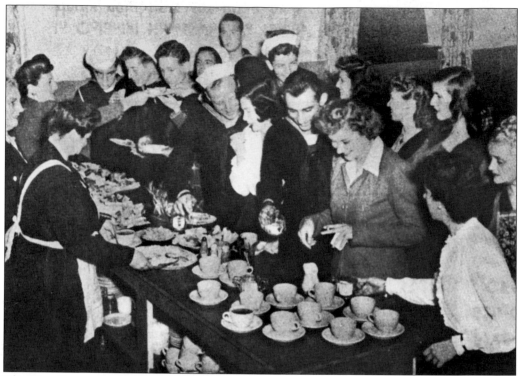

The Five Towns Community Center rolled out the red carpet for World War II servicemen, whether they were local boys or just passing through. USO events, like this reception for visiting sailors, were just one way of saying thanks. Private organizations sponsored luncheons and other events for wounded veterans as the community welcomed the GIs home. (HWPL.)

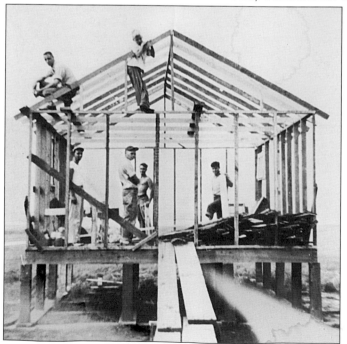

When they came home from the war, "The Desert Rats," a group of friends and relatives who grew up on Woodmere Bay, built themselves a bay house on Nunn's Creek. These members of the Woodmere Fire Department, including some future chiefs, soon became known for their bay house revels and quickly made up for lost time. (Dolores Combs.)

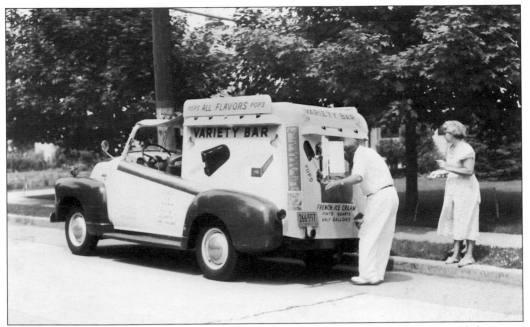

When World War II veterans returned home from Europe and the Pacific, they moved their new families to Long Island in droves, and the resulting boom in new home construction changed the area dramatically. Increased automobile traffic created wealth but also traffic jams on what might have been cow paths just a few years before. (Photograph by Max Hubacher; HWPL.)

The Queens County Water Company emerged in 1890 as the one of the first public water systems, supplying the town of Hempstead's water for domestic use and fire protection. Rock Hall was the first local residence to be served by the new water company. By 1940, the Long Island Water Company's pumping station (shown c. 1948) near Valley Stream managed over 125 wells on 250 acres. (HWPL.)

After the water company's bankruptcy, Franklin Lord of Lawrence purchased the property. Lord's Woods (later Woodmere Woods) extended from the railroad tracks to the Queens border. By the mid-1950s, the construction of homes and commercial buildings had substantially decreased the remaining Woodmere Woods, mobilizing residents to try to create a park or preserve. Robert Arbib's 1971 book *The Lord's Woods* is a poignant chronicle of community efforts to save the woodland. (Photograph by Max Hubacher; HWPL.)

In the 1920s, anticipating the growth of the suburbs, William Gibson began developing the neighborhood that would bear his name. In November 1947, Max Hubacher photographed the progress of this development on Haig Road in Gibson, part of the Hewlett-Woodmere School District. Contractors completed row upon row of identical houses in a matter of months, as demand for suburban housing and the value of the land eclipsed other civic concerns. (HWPL.)

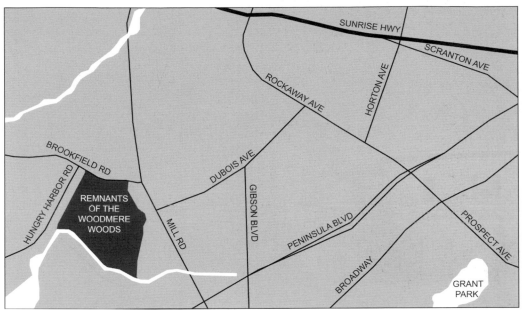

In 1957, the community, mobilized by the efforts of the Woodmere Woods Conservation Committee, tried to save the woodland by petitioning for legislation to establish the area as a park and nature preserve. Political expediency and financial gain defeated their efforts as the last of the forest was bulldozed for homes and a shopping center. Today, the only remnant of the woods is the dark patch at the lower left of the map. (Map created by Lauren Vollono.)

After World War II, the area's Jewish population increased to the extent that the Five Towns has become a nationally recognized center of Jewish culture. Since the 1980s, the population of Orthodox Jews has increased significantly, especially in Cedarhurst, where the shopping district has conformed to the needs of strict Sabbath observers. A current directory of the Five Towns lists 22 synagogues, representing many varieties of Jewish worship, in buildings ranging from converted residences to magnificent edifices like Cedarhurst's Sephardic Temple (above), designed by world-renowned architects. (Photograph by Millicent Vollono.)

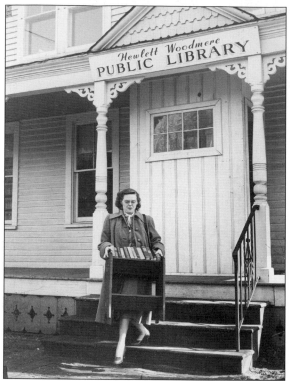

In 1947, voters approved a free library for school district 14 residents. A board of trustees comprised of Charles Hewlett, Edythe Brenner, William S. Pettit, Joseph Rudnick, and Albert Schultz chose Elizabeth Thomson (left) as its first director. After a short period in the Woodmere Elementary School, the Hewlett-Woodmere Public Library moved to a house on Broadway purchased from the Pearsall family, where it was located from 1949 until 1956. (Photograph by Susan Szasz; HWPL.)

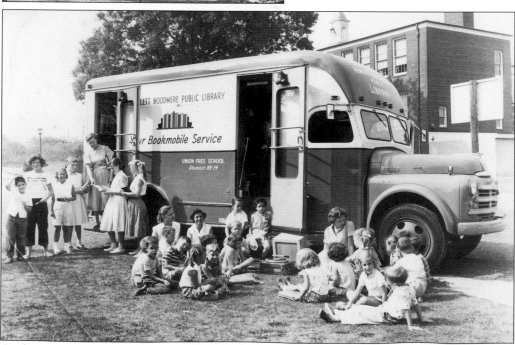

As the community grew, so did the library. With bookmobile service in 1955 and a new building replacing the Pearsall House in 1956, the Hewlett-Woodmere Public Library became a hub of community activity and the Music and Art Co-Central Library for the Nassau Library System. Gold Hall, a concert hall built in 1995, attracts world-class musical talent to the library. (HWPL.)

122

In 1950, voters in School District 15 also approved the creation of a public library to serve their population, and the Peninsula Public Library opened in a house in Lawrence one year later. Horace Bowker of Lawrence was elected chairman of the first board of trustees, which also included Henrietta Preller of Woodmere, Mrs. H. O. Chapman of Lawrence, Lewis S. Jackson of Inwood, and Edward S. Bentley acting as counsel. Marion Humble was appointed the library's first director. (HWPL.)

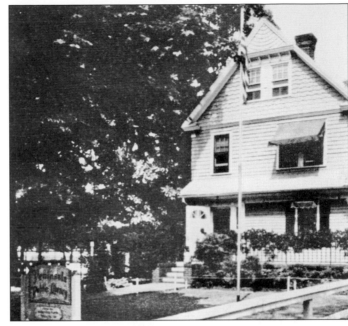

In 1962, a modern library building was constructed on the site of the old house and was expanded in 1981. With the establishment of the two public libraries, the Peninsula Community Library was dissolved and its holdings distributed between their collections. (HWPL.)

A new generation of Five Towns residents depended on the reliability of their automobiles and their mechanics. Fred Russell's Texaco station, located at the corner of Broadway and Stevenson Road in Hewlett, was one of the more picturesque establishments. When this photograph was taken in September of 1960, *The Twist* by Chubby Checker was the number one song and a gallon of gasoline cost 31¢. (Photograph by Max Hubacher; HWPL.)

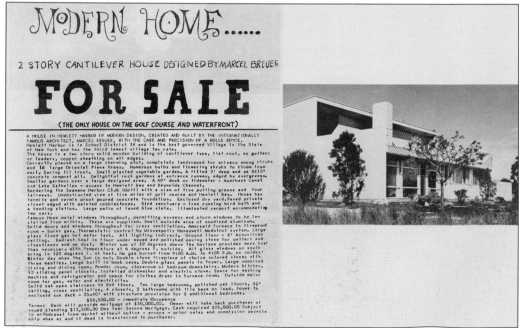

Marcel Breuer was one of several distinguished architects who designed homes in the Five Towns. Art dealer Gilbert Tompkins owned this Hewlett Harbor home from 1946 to 1965. The Tompkins House was one of three homes in the area designed by Breuer. If the purchase price of $58,500 seems a bargain, it should be noted that the average American home in 1965 cost under $20,000. (Village of Hewlett Harbor)

The postwar baby boom created a need for more and larger schools. In 1956, the new George W. Hewlett High School was built on the site of the Hewlett Bay Park steeplechase course. A decline in students in the 1970s and 1980s prompted heated community debates about the use of older school buildings. Woodmere Junior High and Woodmere High School were vacated and eventually demolished, the property sold for condominium development. (Photograph by Max Hubacher; HWPL.)

When 1,000 acres of marshland from the Idlewild golf course were earmarked for development as an airfield, few foresaw that it would one day be the 5,000-acre John F. Kennedy International Airport, which accommodated 47.8 million passengers in 2008. Over the years, local residents have acclimated to planes rattling dishes, shifting pictures, and setting off car alarms as they pass overhead on their approach to the airport. (HWPL.)

IN MEMORIAM OF THOSE LOST FROM SCHOOL DISTRICT #15
AND ALL VICTIMS OF 9-11-01

Neil D. Levin
Exec. Director-Port Authority

Thomas E. Jurgens
Court Officer - NYS Supreme Court

Kevin O'Rourke
Firefighter NYC Fire Dept.

Joseph Rivelli, Jr.
Firefighter NYC Fire Dept.

Bettina Browne Radburn
AON Corp

Ira Zaslow
Lehman Brothers

Before September 11, 2001, the twin towers of the World Trade Center were visible from many points along the shoreline bordering Jamaica Bay. The proximity of the event makes it especially poignant for New Yorkers. Memorials in Cedarhurst Park (above) and at Hewlett High School remember those neighbors who died that day. Victims who attended Hewlett High School were Brett Friedman ('90), Steven Furman ('78), Craig Montano ('80), and Philip Rosenzweig ('72). (Village of Cedarhurst.)

As the population continues to increase, communities like the Five Towns must decide if they will maintain their suburban character or follow Brooklyn and Queens into urbanization. The challenge of the 21st century will be to provide for the needs of a changing society without losing the qualities that have made this a unique and attractive place to live. (Photograph of Central Avenue in Cedarhurst by Philip Vollono.)

www.arcadiapublishing.com

Discover books about the town where you grew up, the cities where your friends and families live, the town where your parents met, or even that retirement spot you've been dreaming about. Our Web site provides history lovers with exclusive deals, advanced notification about new titles, e-mail alerts of author events, and much more.

812.40 8

Arcadia Publishing, the leading local history publisher in the United States, is committed to making history accessible and meaningful through publishing books that celebrate and preserve the heritage of America's people and places. Consistent with our mission to preserve history on a local level, this book was printed in South Carolina on American-made paper and manufactured entirely in the United States.

This book carries the accredited Forest Stewardship Council (FSC) label and is printed on 100 percent FSC-certified paper. Products carrying the FSC label are independently certified to assure consumers that they come from forests that are managed to meet the social, economic, and ecological needs of present and future generations.

FSC
Mixed Sources
Product group from well-managed forests and other controlled sources

Cert no. SW-COC-001530
www.fsc.org
© 1996 Forest Stewardship Council

Find Your Place in History.